"David Worth has written a bawdy and fun-filled account of how Orson Welles may have learned the art of Cinematography during one wonderful lost weekend. If it didn't happen this way, it should have."

— David S. Ward, Academy Award®–Winning Writer, *The Sting*, Writer/Director, *Major League*

"This is a 'graphic textbook' that de-mystifies the black art of Cinematography, and a fascinating fantasy of Orson Welles' approach to shooting *Citizen Kane*. David Worth makes accessible what has always been a mystery to the student and the layman."

— John Badham, Director (*Saturday Night Fever, Wargames, Point of No Return*)

"An absolute cinematic page turner."

— Dennis Hopper, Actor/Director

"This book is a *BIG BAD MAMA* of 'nuts & bolts' filmmaking information… *A NAKED PARADISE* of naughty Hollywood tales and *A BUCKET OF BLOODY* good reading."

— Roger Corman, Producer/Director/Writer

"Most textbooks will put the reader to sleep by page 10 — not this one! The professional knowledge provided in each chapter, along with the scandalous fictionalized story, is simply marvelous. This is not just a textbook, it is a '*graphic textbook*' and a total experience."

— Fritz Manes, Producer (*Outlaw Josie Wales, Firefox, Every Which Way But Loose*)

"An entertaining format makes *Crash Course in Cinematography* a worthwhile read."

— Haskel Wexler, ASC, Academy Award®–Winning Cinematographer (*Medium Cool, Who's Afraid of Virginia Woolf, Bound for Glory*)

"Lively, entertaining, comical, risqué, bawdy, lewd—hardly words that come to mind when one thinks of textbooks. But they certainly describe this fanciful conceit of a book in which the legendary cinematographer Gregg Toland gives a young tyro named Orson Welles a crash course in the ABCs of moviemaking over a long weekend devoted to wine, women, and gambling. By the time you've finished his book, you realize, a little dizzyingly (hungover?), that Worth, a distinguished cinematographer and director himself, has managed the same trick as his great predecessor: pulling a pedagogical rabbit out of a bender of a hat."

— Paul Seydor, Academy Award®–Nominated Film Editor & Author, *Peckinpah: The Western Films: A Reconsideration*

"David… Your great eye is matched by your great writing style. This book is amazing! Easy reading, very informative and VERY funny."

— Larry Spiegel, Producer (*Remo Williams: The Adventure Begins, Sunchaser, The Destroyer*)

"Extraordinary — not a graphic novel, a 'graphic textbook.' The weaving together of the lessons in cinematography and historical facts… is inspired… totally engaging."

— Shadoe Stevens, Radio Star/Actor/Artist

"If you are an up-and-coming DP or Director or Actor, this book is a must read if you are at all interested in improving your work and your performance."

— Rowdy Roddy Piper, WWE Icon/Actor/Author

"An irreverent riff on the myth of wide-open 1940s Hollywood, where booze, drugs, and look-alike call girls provide the scandalous backdrop, as Mr. Toland gives Mr. Welles an askew seminar on the basics of Cinematography."

> — John Bailey, ASC, DP (*The Big Chill*, *Silverado*, *As Good As It Gets*)

"I loved the book… a wonderful trip down memory lane… All of my work with John Frankenheimer was based on a shared love of deep focus and wide-angle lenses. It definitely reminded me of my roots… and why I love doing what I do."

> — Alan Caso, ASC, DP (*Reindeer Games*, *Into the West*, *First Sunday*)

"David Worth has crafted a wild ride through the early histories of Hollywood… In the process of visiting many famous landmarks, beautiful people and enough sex and nudity to make any "B" movie proud, you get the chance to learn the Art and Craft of Cinematography… in a way that you won't forget it… by having a good time."

> — Thomas F. Denove, Director of Photography/Vice Chair/Head of Production/UCLA Department of Film, Television and Digital Media

"A fun and entertaining book dealing with the ABCs of the Art of Cinematography. I highly recommend it to cinema students and the emerging filmmakers."

> — George Spiro Dibie, ASC, Former President, American Cinematographers Guild

"Great title! What an opulent book! I immediately sent it to someone else."

> — Harlan Ellison, Writer. Among his many awards are ten Hugo Awards, four Nebula Awards, and five Bram Stoker Awards, including the Lifetime Achievement Award in 1996

"Welcome to the enticing world of the 4Ts… An unforgettable weekend romp… Read it and learn."

> — Georgia Packard, SOC, Former President, Society of Camera Operators

"This book is a fantastically fun fictional account of the collaboration between director Orson Welles and cinematographer Gregg Toland on the classic film *Citizen Kane*. Dive into this story like you would a dessert. Enjoy it to the fullest."

> — Matthew Terry, Screenwriter and Contributor to *www.hollywoodlitsales.com*

"Drawing on his considerable creativity as well as his experience as a Director or DP on more than thirty films, David Worth lets his imagination run wild in *The Citizen Kane Crash Course in Cinematography*. The result? One of the most fascinating books you'll ever read about filmmaking. The story focuses on how legendary cinematographer Gregg Toland taught 'Boy Wonder' Orson Welles all he needed to know about cinematography before Welles began shooting *Citizen Kane*. It's a fun and enlightening read!"

> — Betty Jo Tucker, Editor/Lead Film Critic for *ReelTalkReviews.com*, Author, *Confessions of a Movie Addict*, *Susan Sarandon: A True Maverick*, and *The Reel Deal: Writing about Movies*

THE CITIZEN KANE

CRASH COURSE IN CINEMATOGRAPHY

A wildly fictional account of how Orson Welles learned everything about the Art of Cinematography in half an hour. Or was it a weekend?

DAVID WORTH

Published by Michael Wiese Productions
3940 Laurel Canyon Blvd., # 1111
Studio City, CA 91604
tel. 818.379.8799
fax 818.986.3408
mw@mwp.com
www.mwp.com

Cover Design: Michael Wiese Productions
Cover Photo: Beverly Hills Hotel provided by
Shooting Star Agency (*shootingstaragency.com*)
Illustrator: Muse Greaterson

Printed by McNaughton & Gunn, Inc.,
Saline, Michigan
Manufactured in the United States of America
Printed on Recycled Stock

Library of Congress Cataloging-in-Publication Data

Worth, David, 1940-
 The Citizen Kane crash course in cinematography / David
Worth.
 p. cm.
 ISBN 978-1-932907-46-9
 1. Welles, Orson, 1915-1985--Fiction.
 2. Cinematography--Fiction. 3. Citizen Kane (Motion picture)
 4. Motion picture industry--Fiction. I. Title.
 PS3623.O773C58 2008
 813'.6--dc22
 2008022840

In memory of
D. W. Griffith,
Orson Welles,
&
Stanley Kubrick

Next to whose
staggering genius,
imagination, and
talent, all others pale

Dedication

To my wife
and family,
whose steadfast
love and support
has made
the impossible,
possible

TABLE OF CONTENTS

FOREWORD

I met David Worth in Sofia, Bulgaria, during two back-to-back productions for the Sci-Fi Channel in 2004—*Alien Apocalypse* and *Man with the Screaming Brain*. The fact that David had a wicked sense of humor put the two of us in cahoots right from the start. Working on low-budget movies, crew members tend to bond from the borderline nightmare experience of trying to film two hours of entertainment in 18 days, so there's a lot of salty, "gallows" humor present on the set. Waiting between shots in a gravel quarry, David referred to a bad movie we were discussing as "hammered shit." I knew we were going to get along just fine.

It was a pleasure to work with "Dr. Worth" (as I came to call him in my delirium) for two months of challenging filming in a bizarre country. We shot in a wide variety of locations — everywhere from forests to canals to an incomplete Communist-era subway tunnel — and David figured a way to photograph it. I marveled at the speed and economy of his lighting. To this day, he's the fastest Director of Photography I've ever worked with — and one of the more rational and pleasant I might add (producers, are you listening?).

So, when David mentioned that he had written a book, I was intrigued, as I had gone through that process myself. When I got around to reading it, I was thrilled to find it as sharp and funny as the man himself and positively riddled with invaluable filmmaking information! Readers will enjoy the great "what if" story on several levels and will hopefully come away with a greater appreciation for what Cinematography is and for what Cinematographers have contributed to the art of motion pictures.

<div align="right">

Bruce Campbell

Oregon

</div>

Among his numerous movie and TV credits, Bruce Campbell has been the star of the Sam Rami films *Evil Dead* and *Army of Darkness*, and has cameos in all three *Spider-Man* films. He has also starred in the TV series *The Adventures of Brisco County, Jr.*, *Xena Warrior Princess*, and *Hercules*, and can currently be seen in *Burn Notice*. His credits as an author include *If Chins Could Kill: Confessions of a "B" Movie Actor*, *Man with the Screaming Brain,* and *Make Love the Bruce Campbell Way*.

ACKNOWLEDGMENTS

There are always many factors and influences that go into making any book a reality and often authors will go all the way back to their first teacher or go digging into their family history to make sure that they thank everyone who has ever encouraged them to become what they have become. In this case, however, there are really only three outstanding elements that have made this book possible.

First, this book is actually the brainchild of Michael Wiese and Ken Lee, the extraordinary gentlemen who call the shots at MWP and who have published many outstanding books about the filmmaking process and independent film production. Having not accepted my initial efforts, they nevertheless did not give up on this fledgling author but instead suggested that I write a book on Cinematography, realizing that I was fairly recognizable in this arena having been the Director of Photography on two films with the Icon of Icons in the Hollywood film industry, Clint Eastwood. Once we agreed to agree, Michael and Ken gently yet firmly ushered me kicking and screaming into the world of international publishing, and their professionalism, wise counsel and expertise were invaluable in the creation of this work.

Second, I am grateful to Dean Bob Bassett, whose purpose, scholarship and dedication were an absolute inspiration, as was the incredible Dodge College of Film and Media Arts at Chapman University, its faculty and student body. I was a new member of the team there and wanting to both make a good impression and do a good job instructing my students. I was always at the computer in the Adjunct Faculty office, or elsewhere. I worked from very early in the morning until very late at night and after preparing my class assignments, I would diligently work on this book. See, your parents were right when they told you to turn off the TV and spend your time more productively.

Third, none of the above would have ever happened, if it weren't for one of my oldest and dearest friends in the film business, Professor Gil Bettman. Gil and I met more than twenty years ago, when I was the DP on a feature, *Never Too Young to Die*, that he was directing. We had a fabulous collaboration and over the years, and we always stayed in touch. After Gil found his way into the "Ivory Tower" of academia, he was very persistent in trying to convince me that this was something that I should pursue. Finally the timing was right, Chapman needed someone for a semester, and I was available. Then, realizing that I also needed to "publish" if I wasn't going to "perish," Professor Bettman did me the honor of introducing me to Michael Wiese at MWP. Now we seem to have come full circle and truthfully, this entire acknowledgment should only be to one person. So thanks again, Gil, from the bottom of my dark little filmmaker's heart and as of right now — I owe you one!

DW

PREFACE

"The more things change the more they stay the same"

While this saying holds true in many situations, where I believe it holds true most often is in the arena of professional filmmaking, especially when it comes to the work of the Director of Photography, also known as the Cinematographer.

From the very dawn of cinema history when Billy Bitzer was panning and tilting, as Karl Brown was hand-cranking the Pathé camera in front of the immense walls of Babylon for D. W. Griffith and *Intolerance*, to Gregg Toland capturing the depression in stark black and white with his customized blimped Mitchell BNC for John Ford and *The Grapes of Wrath*, to Robert Surtees capturing the chariot race in Ultra Panavision 70mm for William Wyler and *Ben Hur*, to Raoul Coutard hand-holding his Éclair while being pushed in a wheelchair by Jean-Luc Godard for *Breathless*, to John Cassavetes shooting in 16mm black and white in his spare time for *Faces*, to Anthony Dod Mantle shooting in downtown London with the Canon XL1's for Danny Boyle and *28 Days Later,* to Ellen Kuras shooting Sony HD-CAM's for Rebecca Miller and *Personal Velocity*, to Scott Coffee shooting Naomi Watts with his home video camera for *Ellie Parker*, to Adam Biddle, Mark

Neveldine, and Brian Taylor shooting the Sony F950 "Nanocam" in a backpack so that they could capture their nonstop *Breathless* of the new millennium *Crank*, on rollerblades! From 16mm to 35mm to 70mm to video to home video to HD, the one thing that has always stayed the same is that it has always been a man (or a woman) and a camera.

Today's technology is advancing so rapidly that soon someone will be capturing a TV series or even a blockbuster with their cell phone but it will still be a man or a woman or maybe even a teenager in China with a camera — only this time on their cell phone. Then the material will be edited, scored, and finished on their PC or Blackberry, the result will immediately be uploaded to the Web for distribution, and it will have a million hits by the weekend.

Presently with nearly everyone who's interested owning an HD camera and having Final Cut Pro or something similar on their computer, the media, especially when it comes to motion picture production, has been totally democratized and demystified. However, that process began many, many years ago at the RKO Studios when a young man named Orson Welles convinced another young man named Gregg Toland to teach him all about the Art of Cinematography. Mr. Welles would later tell his admirers that it only took half an hour — but it actually took longer.

What follows, dear reader, is totally a work of fiction, an apocryphal story that was allegedly told to me by Adrian Moser of Cine Service over an exceptional dinner and several rounds of martinis at the Musso & Frank Grill on Hollywood Boulevard one very long evening way back in 1972. Adrian Moser was already in his 70s when I met

him as a young cinematographer in the late 1960s. I had photographed and edited a black and white and color 16mm art film called *The Bach Train* and Adrian was the gentleman, back in the day, who specialized in delivering to his customers a timed 35mm inter-negative from your original 16mm film. Adrian had done our blow-up from 16mm to 35mm and had also timed all the sequences, corrected the density, and in many cases cropped the shots to make us all look good.

What had ultimately sold me on Adrian as a maven of Hollywood lore and insider information was the fact that, while still a student at USC, way, way back in the day, he had screened an over six-hour-long print of *Intolerance*, for Mr. D. W. Griffith and Miss Lillian Gish themselves. Over his many years in Hollywood Adrian had kept his eyes and ears open and he knew first hand where a lot of bodies around town were buried and exactly in whose infamous closets the skeletons lurked, ready and waiting to be found.

Adrian and I would get together every few months to chat about the grand old days of Hollywood. We would always meet at the Musso & Frank Grill, where it seemed to us that the spirits of Griffith, von Sternberg, Ford, and many of the original Hollywood legends who had made this establishment famous, still lingered nearby waiting to once again order that well-publicized, and much sought-after perfect martini.

On this particular evening as the martinis continued to flow the conversation kept coming back to *Citizen Kane*.

Adrian opined that it all started one Friday afternoon in 1940 when the Academy Award–winning Director of Photography, Gregg Toland, sought out "The New Kid" at

RKO, Orson Welles. He approached the unapproachable Mr. Welles in the RKO commissary in order to convince the "Boy Wonder" to choose him as the cinematographer for his first Hollywood feature film: *Citizen Kane*.

I reiterate (again) that this is entirely a work of fiction, told as an apocryphal story of that historic meeting that was only supposed to have taken several minutes, but which I'm told stretched into an orgiastic weekend of legendary proportions, during which the soon-to-be icons — Welles and Toland — were rumored to have consumed nearly a case of imported Irish whiskey, roasted an entire pig, and both ended up naked with a half dozen celebrity look-alike call girls in the pool at the Beverly Hills Hotel!

Which brings me to my Disclaimer: This is an R-rated story and if you are easily offended it may even be X-rated. It uses the coarse language that is normal for many movie sets and film crews and depicts the kinds of attitudes toward woman that existed in the pre-Women's Lib, pre-Politically Correct, pre-Civil Rights world of Hollywood in the 1940s. It is meant to instruct and mostly to entertain as it dramatizes the excessive lifestyle that a megastar like Orson Welles may have indulged in. One, I surmise, that is actually not so very different from the way many privileged celebrities or politicians choose to live their lives today.

If this kind of graphic material offends you, then I urge you to read no further.

That having been said, this whole amazing story actually started, as Adrian Moser emphatically told me, with *War of the Worlds.*

The New York Times

NEW YORK ·MONDAY· OCTOBER 31. 1938

P P

Radio Listeners in Panic, Taking War Drama as Fact

Many Flee Homes to Escape "Gas Raid From Mars"—Phone Calls Swamp Police at Broadcast of Wells Fantasy

OUSTED JEWS FIND REFUGE IN POLAND AFTER BORDER STAY

WELLES ON THE RADIO / WAR OF THE WORLDS HEADLINE

ACT I
THERE BUT FOR THE GRACE OF GOD

The Orson Welles phenomenon that swept across America in 1939, after he had unleashed his radio play based on the H. G. Wells book *War of the Worlds*, was astounding, and the executives in Hollywood basically saw nothing but big box office dollars looming up on their horizons. So much so that RKO Studios more or less offered Mr. Welles *carte blanche*, even tossing in the unheard-of addendum of having "Final Cut" on his very first feature film. The additional perks, which enabled their new resident genius to remain

deliriously content, gorging himself on imported whiskey, filet mignon, and call girls in the Presidential Suite at the Beverly Hills Hotel — well, this seemed to the RKO executives a small price to pay for having the Boy Wonder and their newly appointed Cash Cow securely inside their darkened sound stages, making them a movie.

Gregg Toland was eleven years older than Mr. Welles who was just twenty-five years old in 1940. Over the preceding twelve years, Toland had amassed more than fifty feature film credits and by the age of only thirty-six he was already an Academy Award–winning cinematographer. He was considered to be at the very top of his game and was also thought to have few, if any, peers in the Hollywood community.

Still, even with all of that experience and adulation, Toland somehow knew that if he attained this film with the "Boy Wonder," Orson Welles, it would place him into another league altogether. Maybe it was because of the stir that Welles had caused with his *War of the Worlds* hysteria or maybe it was simply because of his age and the fact that he was the youngest Hollywood director ever. Whatever the reason, and whatever the cost, Toland knew that he had to photograph what would become *Citizen Kane*, and he had already resolved not to let anything knock him off course

Toland had been around the block in Hollywood. He had seen and done plenty, so he wasn't easily shocked. He didn't care if Welles was drunk, he didn't care if Welles took drugs, he didn't care if Welles f#%ked every actress and actor in the Screen Actors Guild in front of him twice, he didn't even care if Welles donned a bed sheet with KKK scrawled

on the front of it and then whistled "Dixie" out of his ass. Toland just didn't care, he would not be deterred, and nothing was going to keep him from his destiny.

Gregg Toland was born in May 1904 in Illinois, Orson Welles was born in May 1915 in Wisconsin. These two Midwest, middle Americans guys, who were already titans of entertainment, Welles in the theater and radio and Toland in the movies, were about to join forces. The result would become what most experts on "The Cinema" still consider to be "The Best Film Ever Made" and most certainly the most advanced piece of cinematic art that had been created up to, including, and well beyond that point in time.

Int. — RKO Commissary — Day

Gregg Toland cautiously approaches Orson Welles at his corner table in the commissary. It is already after lunch and the place is nearly empty, except for Mr. Welles who is presently having his second rib eye steak cooked rare and is washing it down with a tumbler glass of whiskey, while behind him a tuxedoed waiter stands dutifully by. In one graceful motion Mr. Toland places his Academy Award down on the table.

 Gregg
 That's the Academy Award, Mr. Welles.

 Orson
 I know what the f#*k it is, Gregg, I'll have
 three of those doozies by this time next year.

 Gregg
 I won it working with Willy Wyler... I
 should have won it working with Mr. Ford...
 and I'd like to win another one working with
 you, Mr. Welles.

Orson
Only three great American Directors, Gregg...
John Ford, John Ford, and John Ford.

Gregg
I won't argue with you... but I think that I can
help you become the next great American
Director, Mr. Welles.

Mr. Welles liked the sound of that; he liked it well enough to refrain from placing the next morsel of rare rib eye into his mouth, smile and unctuously gesture for the Academy Award-toting cameraman to sit down.

Orson
Sit, Gregg... have a drink.

Gregg
Whatever your having, Mr. Welles, only
I'll have a double.

Mr. Welles regarded his tumbler glass of whiskey as though he had just been given a challenge, albeit one that he could easily handle and no doubt better.

Orson

Spoken like a true professional... Hastings...

Hastings, who gave the impression that he had been predestined by The Creator to fawn over the Boy Wonder's every culinary desire, flicked a bit of lint off of his impeccable tuxedo, then adeptly poured Mr. Toland two large glasses of whiskey. Gregg immediately polished off half of the first glass and smiled at Mr. Welles.

Gregg

Fifty films, Mr. Welles, I've already done
fifty feature films and most of them were
pretty big deals too.

Orson

Bullshit. Most of them were studio drivel
and you know it. The only good ones were
Les Miserables, *Dead End*, *Wuthering Heights*,
and *The Grapes of Wrath*.

Gregg forces a half smile and then finishes off his first glass of whiskey.

> Gregg
>
> Thanks for giving me credit for four films
> out of the fifty... By the way I got most of
> my acclaim for one of the films that you
> apparently didn't like, *The Long Voyage Home*.

Mr. Welles savors another succulent bite of rare rib eye before answering.

> Orson
>
> Too homoerotic for my taste, Gregg... big men...
> on a big boat... big deal.

> Gregg
>
> And they say Mr. Ford is an SOB.

> Orson
>
> Do they? Then maybe that's what it takes.

Gregg starts in earnest on his second glass of whiskey as he casually cleans a smudge off his Academy Award and muses to himself.

> Gregg
>
> It's not all that complicated, Mr. Welles.

> Orson
>
> Oh, for Christ's sake, Gregg call me Orson.
> All this "Mr. Welles, The Boy Wonder" stuff is
> just so much bullshit.

> Gregg
>
> That's not what Mankiewicz says.

Mr. Welles smiles at the mention of his maverick co-screenwriter on *Citizen Kane* and gestures for more whiskey. Hastings never misses a beat as he silently and precisely refills the Boy Wonder's glass, then turns to the Academy Award winner. Gregg nods and he also receives another brimming glass of the imported spirits.

> Orson
>
> Herman, that lush... so what does the
> "Oracle of the San Fernando Valley"
> have to say?

> Gregg
> Mank' says whenever he sees you prowling
> the various sound stages with your cape blowing
> in the wind, "There but for the grace of God...
> goes God!"

Orson chortles loudly, causing Hastings to imperceptibly raise an eyebrow as Mr. Welles then hastily sops up the succulent remnants from his rib eye with several pieces of sourdough bread, and not wanting to waste a drop of the amber sauce hurries them into his mouth.

> Orson
> The old f#%ker's probably right.

Orson pauses to swallow the tasty morsels, then he locks eyes with Gregg who attentively waits for Mr. Welles to continue.

> Orson
> You want to shoot my movie, right, Gregg?
> And by the way what's... "not all that
> complicated?"

Gregg

Yes, I want to shoot your movie... and
learning how to make movies, Orson, it's
actually not all that complicated.

Orson

Fine. Here's the deal then... I know nothing
at all about filmmaking... I've got a big ego
and a bigger IQ, I'm a quick study and I want
you to teach me what you know.

Gregg leans back savoring the moment, weighing the offer. Then he takes a long, slow
quaff of his whiskey.

Gregg

That's really the reason that I want to work
with you, Orson... because the only way to
learn something... is from someone who
doesn't know anything.

Orson smiles at this young man's wisdom and insight as Gregg takes another slug of whiskey and continues.

> Gregg
> Cinematography, Mr. Welles... Orson... it's like
> becoming a concert violinist... it takes a lifetime
> of... practice... of sacrifice... of dedication...

> Orson
> OK, that's the "*Life* magazine" answer Gregg...
> Now cut the bullshit and give it to me straight...
> How long?

Gregg sees that Mr. Welles is deadly serious. He takes a deep breath, then glances at Hastings, who knowingly nods, then turns and busies himself with a bottle of bitters. Gregg guardedly looks around the empty commissary to make sure that nobody hears what he's about to say, then he leans in close and whispers.

> Gregg
> Two days...

<div style="text-align:center">

Orson

</div>

You've got a deal...

<div style="text-align:center">

Gregg

</div>

Starting now?

<div style="text-align:center">

Orson

</div>

Starting sometime tomorrow... Now we're
busy... Now we're getting drunk...

They both manage a smile as Orson raises his glass and moves it forward, Gregg does the same and the two titans of entertainment — toast.

<div style="text-align:center">

Orson

</div>

"There but for the grace of god... goes me!"

<div style="text-align:center">

Gregg

</div>

Amen!

They drain their glasses and smile at their mutually beneficial arrangement. Before calling an end to his repast, Orson first insists on a crème brûlée and then that Gregg have the RKO Studios send whatever movie equipment they might need to his Presidential Suite at the Beverly Hills Hotel. He also insists that Gregg call his wife, mistress, girlfriend or whomever else he might spend his precious free time with to let them know both singularly and collectively that he would not be around at all during the entire weekend and not to try to call or to contact him under any circumstances unless, of course, the Second Coming of Christ Himself occurred and possibly not even then!

ORSON SMILING

THE BEVERLY HILLS HOTEL

ACT II
TOES, T%&T, T#TS, TEETH

The Beverly Hills Hotel opened in 1912 and by the 1920s it had already become a glamour establishment that attracted stars like Charlie Chaplin, Gloria Swanson, Rudolph Valentino, and the honorary mayor of Beverly Hills, Will Rogers. It was known for its secluded bungalows that were used by celebrities for their many and assorted trysts. Being located above Sunset Boulevard somehow made it seem more remote than it actually was, which usually gave rise to a kind of wild abandon by those guests who frequented its spacious suites, dark hallways, intimate restaurants, dimly lit lounges, and aforementioned bungalows.

The El Jardin Restaurant wouldn't become the Legendary Polo Lounge for several more years when Mr. Welles took up his residence in the Presidential Suite, in 1939. After all, nothing was too good, it seemed, for the "Boy Wonder" who had brought the American public to their collective New Deal knees with his infamous *War of the Worlds* Halloween prank. Soon afterwards all of the studios had come calling, courting him to work his magic once again by enticing that same elusive public to flock to their neighborhood theaters in droves to see the Boy Wonder's first Hollywood Movie

SWISH PAN TO: The Brown Derby Restaurant. Where presently our two about-to-be cinematic legends were busily getting drunk — privileged-Hollywood-celebrity drunk. Welles had his studio driver Ernesto drive them to this Hollywood hot spot first. Situated on Vine Avenue near Hollywood Boulevard, it was close to many of the major studios and always seemed to be packed with stars. The gossip gals Hedda Hopper and Louella Parsons each had their own tables here where they would often pontificate, but obviously from opposite sides of the opulent, star-studded room. It was only last year in booth number five that Clark Gable had asked the lovely Carol Lombard to be his wife and that the Boy Wonder himself had made this easily identifiable landmark one of his favorite hangouts.

THE BROWN DERBY

MUSSO & FRANK GRILL

Orson would usually hold court here several nights a week in one of the main booths beneath the legendary caricatures of the Hollywood famous and infamous. When moved by the spirits or the champagne, he might actually stand on one of the tables and amuse the gathered throng of celebrities with a variety of his magic tricks.

This afternoon however was different. The Derby was surprisingly empty as an inebriated Welles began waving around Toland's Academy Award like it was a Cossack's saber, eventually shoving it into his pants and pretending like it was his cock. At which time a flaxen-haired starlet with her boobs aching to make an appearance through the top of her mostly unbuttoned dress attempted to perform fellatio on the cold golden and unsuspecting statuette. Toland, ever the observer, sat cross-legged on top of the bar laughing fitfully and tossing ice cubes in the general vicinity of the starlet's cleavage.

SWISH PAN TO: Musso & Frank Grill at 6667 Hollywood Boulevard, Hollywood's oldest restaurant. When it opened in 1919 it became the watering hole for the very founders and inventors of the language of motion pictures: D. W. Griffith, Erich von Stroheim, Charlie Chaplin, John Ford, Joseph von Sternberg, "Wild Bill" Wellman, Howard Hawks, and Cecil B. DeMille. Here Mr. von Sternberg, while having his breakfast one morning, received a career-changing phone call from Mr. Chaplin. Here the likes of Fitzgerald, Faulkner, and Hemingway commiserated as they drank away their collective screenwriting aggravations and here tonight we discover that Misters Welles and Toland have ordered nothing less than an entire pitcher of the famous martinis.

As Orson performs his amazing card tricks for the bartender and nearby clientele, he and Toland both attempt to imbibe from the pitcher of martinis with an assortment of straws. This inevitably leads to them holding the rarified liquid in their mouths, then blowing it at one another and convulsing with laughter. Eventually Welles manages to get both ends of the bar wagering against each other on the outcome of one of his show-stopping card tricks as Toland carefully weaves his way toward the bathroom. Finding the trusty phone booth on the way, he decides to relieve himself there instead.

SWISH PAN TO: The Hollywood Roosevelt Hotel whose Blossom Room hosted the very first Academy Awards, which unlike today's event was a brief five-minute ceremony hosted by Douglas Fairbanks and Al Jolson. As his Bentley pulls up to the front of the famous establishment, Welles instructs Ernesto to wait while he and Toland attempt to crash whatever party they can manage to foist their inebriated celebrity selves upon.

Inside they find the Zagfields' wedding reception and soon after pronouncing it "boring" they acquire a tray laden with champagne and scurry off down one of the many opulent hallways. Several glasses of the bubbly later they discover a room filled with middle-aged drag queens dancing to a phonograph record of Marlene Dietrich singing "Falling in Love Again." Welles and Toland share a conspiratorial look as Welles feigns to pompously carry the tray of champagne, they both move through the din of dancing divas, and Toland awards whichever couples they deem to be the "best in show"

THE HOLLYWOOD ROOSEVELT HOTEL

WELLES AND TOLAND BEADS AND GLITTER

free glasses of the bubbly. Their gesture is greeted with squeals, giggles, kisses on the cheek, ladies hats, a feather boa, and fake jewelry as Marlene's husky voice accompanies the ensuing gaiety.

SWISH PAN TO: The Beverly Hills Hotel Presidential Suite where Welles and Toland enter looking like something that Ed Wood might drag in and come face-to-face with a room full of film equipment. Apparently RKO Studios, at Toland's insistence, had already placed his own customized Mitchell BNC 35mm camera mounted on a geared head and small dolly, an empty 1000-foot magazine, a fresh roll of Kodak Panchromatic Double-X film, his personal case of Vard Opticoated Cooke and Astro lenses and filters, an incident light meter, several lights and reflectors on stands, some assorted silks, flags, and a blackboard, all in the area of the suite's living room.

Welles and Toland regard each other and, realizing that they both look a bit the worse for wear, Orson utters two words before allowing the festivities to continue.

Orson
Steam bath...

Fade Out/Fade In:

One hour later, back in the Presidential Suite steamed and massaged, Welles decides that he's now ready for Lesson Number One. Toland, however, is nearly out on his feet and wants to do nothing more than to get some much-needed sleep. The Boy Wonder won't hear of it; he bellows that sleep "is for the mediocre" and that no one working with him ever has "normal hours." Did van Gogh or Gauguin have normal hours? Then Welles offers Toland one of his little white pills. Toland looks at it and wonders if he should, then quickly realizes that he must and immediately swallows it as Welles orders a cart of fresh fruit and a pot of freshly brewed coffee.

Dissolve To:

Twenty minutes later: Now they are both partaking of the ample fruit cart while between bites Toland is manically writing an incomprehensible series of words and numbers on the blackboard:

1 Inch Toes 24mm. 2 Inch T%&t 50mm. 3 Inch T#ts 75mm. 4 Inch Teeth 100mm.

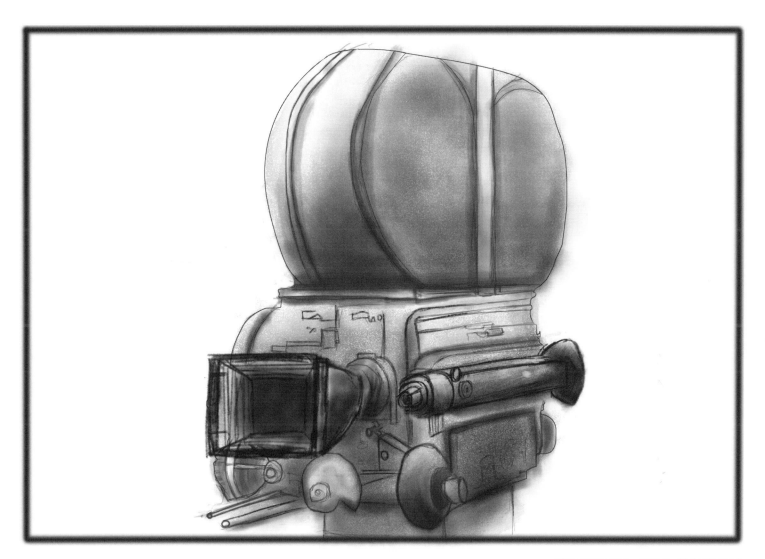

MITCHELL BNC CAMERA

Requesting the Boy Wonder's attention, Toland opens his personal lens case and carefully takes out the lenses one at a time, showing Welles that each one is inscribed with its particular size on its cover: 24mm, 35mm, 50mm, 75mm, 100mm, 150mm. Welles nods, already bored, as Toland, looking around for a suitable subject, states that they should probably have some "stand ins."

Welles eagerly clasps his hands together, immediately perking up at the suggestion, then picks up the phone and asks for "Gaylord." There is a pregnant pause — then when Madam Gaylord comes on the line, Welles asks her to kindly have "Marlene, Greta, and Jean" summoned to his Presidential Suite post haste. As Welles hangs up the phone and paces with boyish anticipation, Toland begins by explaining to him that "The movies are all about one thing and one thing only — telling a story visually and photographically with shots: long shots, medium shots, close shots, and very close shots."

Toland pauses for a slug of coffee, then continues, "The job of the Director of Photography and the Director is to take enough shots or camera angles or coverage of every scene to make it visually interesting and so that it can be cut together seamlessly by the Editor." Who was in Toland's expert opinion actually an "asshole" who mainly sat in a cool dark room and complained about how many frames the slates were, while he and his crew were busting their asses out in Oxnard or Tarzana trying to help some inept director make his day!

Welles is nodding and smiling but not really comprehending when, as the gods of luck and timing would have it, there's a knock on the door. Welles briskly moves to

open the massive portal, then escorts the three striking call girls into the Presidential Suite. They look exactly like Marlene Dietrich, Greta Garbo, and Jean Harlow. At first Toland can't believe his eyes and wonders what was in that little white pill that Welles had given him. Then he catches on and asks Orson to kindly place the "ladies" over by the doors to the patio.

The "ladies" are all wearing long, silken bathrobes and as Welles moves them toward the patio doors he deftly removes their wrapping, leaving them in their bras and panties except for Jean, who's wearing neither. Welles carefully places Jean and her flawless bare breasts and naked torso between Marlene and Greta feeling that, somehow, it just seems to have the right symmetry.

Now Mr. Toland begins in earnest to explain the origins of "Cinematography" to Mr. Welles by first defining the word: "Cinematography comes from the Greek words *kine*, movement, and *graphos*, writing, and writing with movement is what the Cinematographer or Director of Photography does by making the choices of lighting, lenses, film stock, camera placement, camera movement, coverage, and continuity. First, let's examine the basic tools of the trade."

THE MITCHELL BNC CAMERA / MOVEMENT

"Number One: The Mitchell BNC Camera," Toland states as he opens the door on the side of his personally customized camera and explains to Mr. Welles that most of the technical stuff that he is about to relate will be handled by the camera assistants, but that he wants Orson to at least be aware of the process. He continues by showing Mr. Welles the path that the film takes over the rollers and sprockets that hold it in place and that move the unexposed film from the front of the dark, tightly sealed magazine, past the film gate where it is firmly held twenty-four times every second by the pressure plate and briefly exposed for approximately 1/50th of a second to the light intermittently coming through the lens past the revolving shutter. Then the exposed film and its precious latent image are quickly carried by more rollers and sprockets back into the rear of the dark, tightly sealed magazine, ready for unloading and processing at the laboratory.

"Number Two: The Film Magazine." Toland picks up the empty 1000-foot magazine, unscrews the covers, and shows Welles where the fresh, unexposed film is loaded into the left side. He then points out where the end of the film is pushed though a light-tight slit, where a small loop of film is left on the outside of the magazine in order for the film to be threaded into the camera. Then where the end is pushed back through another light-tight slit into the right side of the magazine and fastened to the take-up roller. The magazine covers are closed tightly to prevent any light leaks and then it is ready to load onto the Mitchell camera. Toland cautions Welles that this loading of the film is so critical and important that it is only done by a highly trained and qualified "Film Loader" in a totally darkened loading room. Then he fastens the empty magazine onto the camera and once again shows Welles the path that the film would take through the inside before he snaps the door shut.

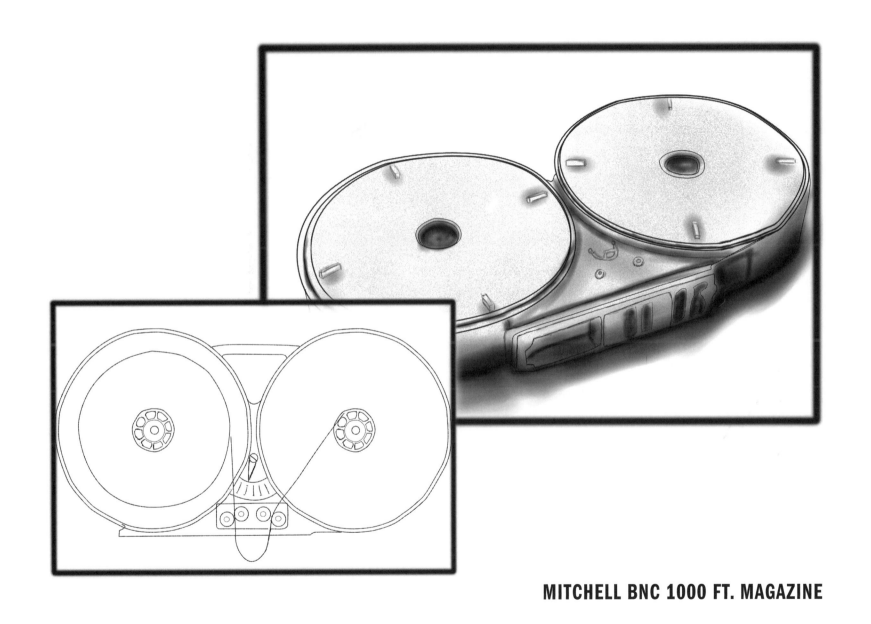

MITCHELL BNC 1000 FT. MAGAZINE

"Number Three: The Film." Toland holds up the can of new, unopened, unexposed film as though it were the Eucharist. This particular can was Eastman Kodak 35mm, 5222 Double-X Panchromatic Film that wouldn't even be introduced for several years but since he was Gregg Toland....

"This is what all the fuss is about," Toland explains, "the film. All of the equipment and sets and locations and wardrobe and makeup and props and scripts and stars and acting and directing are all captured by the Cinematographer, the Director of Photography, on this precious roll of film." Toland kisses the can of unexposed, unopened film and then gently sets it down.

"After it's exposed the film is unloaded from the magazine in the dark loading room by the Film Loader and sealed into its light tight can. It then goes to the laboratory where it's processed and printed, and then the assistant Editor places it in synchronization with the sound track. After that all the rest of the bullshit happens." Toland pauses and as Orson nods he continues, "the editing, the dialogue and sound effects, the music, the titles, the special effects. Eventually the original negative is cut, the sound is mixed, final prints are made by the lab, and the finished film is shipped off ready to be viewed by the adoring popcorn-munching and cola-swigging public at a theater near you."

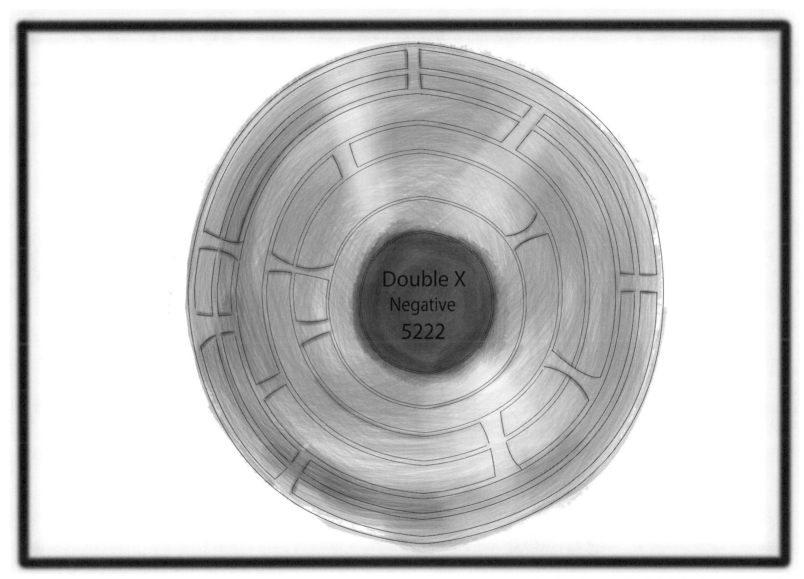

EASTMAN DOUBLE X 35MM FILM

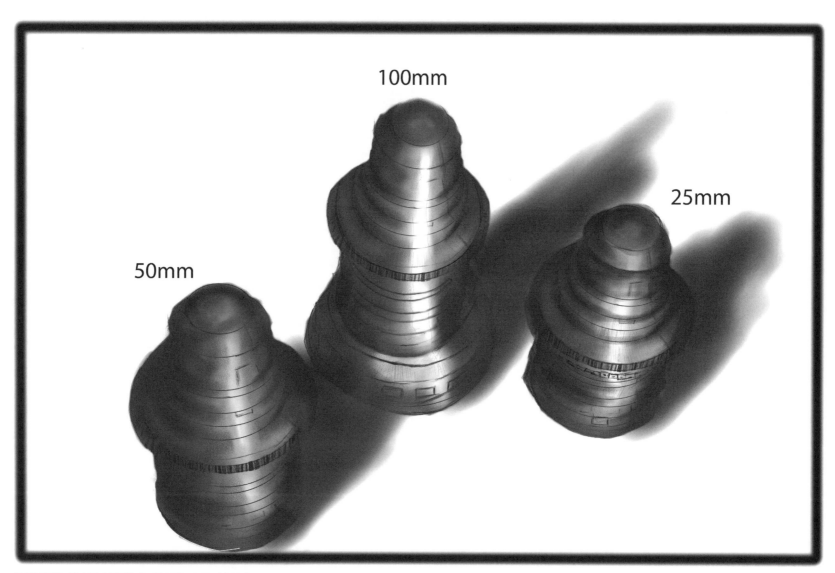

100mm

50mm

25mm

35MM MITCHELL BNC LENSES

"Number Four: The Lenses." Toland states as he picks up the 24mm lens. "This is the one inch, you do not need to know anything about the theory or the history of lenses, how lenses are made or the fact that certain painters like Vermeer were probably setting up their paintings through lenses, all you need to know is what's on the blackboard." Toland gestures to the blackboard, stating, "One Inch Toes 24mm." Toland then shows Welles how the 24mm lens fits onto the front of the Mitchell Camera and is locked into place.

Then Toland moves behind his BNC camera and uses the small handle on the back to "rack over." This patented Mitchell system allowed the Director of Photography or Camera Operator to slide the main body of the camera sideways, away from the film plane, in order to view directly through the lens for critical focusing and framing. Care had to be taken to always remember to "rack back" so that the film itself would be in position to do the take when the camera was "rolled," and then the Camera Operator would observe the scene through a side-mounted Parallax Viewer.

Finally, Toland uses the wheels on the geared head on which the camera was mounted and expertly moves the Mitchell toward Marlene, Greta, and Jean, who are all kind of jiggling, giggling, and caressing one another. Then he asks Welles to look at the image size of this first "shot" through the camera's through-the-lens viewfinder. Welles observed that he could see all three ladies from their "heads to their toes." "Right," Toland tells him, "the one-inch 24mm lens is for wide shots of a location or a set or to see the

WIDE SHOT "STAND IN" HEAD TO TOE

actor's full figure." Welles smiles and nods, then looks at the blackboard in anticipation of the next lens and says to himself, "Two Inch T%&t 50mm."

Toland offers Welles the "two-inch" 50mm lens, then removes the 24mm lens from the front of the camera and has Welles place the 50mm lens in place and lock it down. Then they both quickly look at the image size through the camera's viewfinder. Now Welles sees that the ladies are cut off at the thighs. "Head to T%&t," Welles muses to himself, "This isn't so hard after all." Then Mr. Welles smiles as he once again glances at the blackboard.

MEDIUM SHOT OF "STAND IN" HEAD TO T%&T

"Three Inch T#ts 75mm." Toland states as he offers Welles the new lens, this time the 75mm. Then he removes the 50mm lens and Welles quickly mounts the 75mm, locks it down and hurries to look at the image through the viewfinder. Toland places his hand on Welles's shoulder and stops him, then loosens the wheels on the geared head and shows the Boy Wonder how to move them to make the camera pan left or right or tilt up and down.

Welles quickly gets behind the camera, turns the wheels and tilts the camera down from an awkward head and shoulders shot of Marlene to a pleasing shot of Garbo that includes her breasts peeking through her bra at the bottom of the frame. "Head to T#ts," Welles quietly states, then he continues to turn the wheels panning and tilting the camera to another closer shot of Jean's flawless breast and delightful p#$$y.

CLOSE SHOT OF "STAND IN" HEAD TO T#TS

Toland taps Welles on the arm to get his attention away from Jean's intriguing genitalia and back to the job at hand. When Welles finally looks up, Toland compliments him on his framing and tells him that he has, "An innate sense of composition — which is a talent." Toland opines "that you either have or do not have, it simply cannot be taught." Then he points to the blackboard, one lens left: "Four Inch Teeth 100mm," Welles states. Then Toland has him remove the 75mm lens, which he hands carefully to Toland, and replaces it with the 100mm lens. After locking it down, Welles moves to look through the camera. The image happens to be a shot of Jean's alabaster thigh and Welles slowly moves the wheels on the geared head tilting the camera up going caressingly by her lovely breast and finally framing a very close shot of Dietrich who Toland now asks to smile. "Head and Teeth," Welles says calmly.

VERY CLOSE SHOT "STAND IN" HEAD AND TEETH

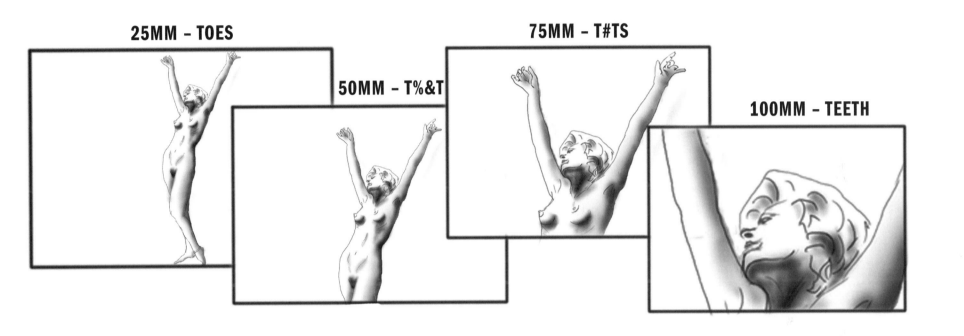

25MM – TOES

50MM – T%&T

75MM – T#TS

100MM – TEETH

FOUR SIZES ON "HARLOW" 24/50/75/100MMS

Welles smiles at Toland and acknowledges that he understands Lesson Number One by reciting: "The camera, the magazine, the film, and the lenses. Toes, T%&t, T#ts, Teeth. The sizes of the shots and the lenses used to shoot them: wide shots one inch 24mm, medium shots two inch 50mm, close shots three Inch 75mm, and very close shots four inch 100mm."

Toland nods approvingly. Orson, remembering that the 100mm lens is still on the camera, then quickly turns the wheels and tilts down to a very close shot of Jean's adorable p#$$y. Moaning to himself and licking his lips like a kid in a candy store, Orson finally bellows in his best commercial advertising radio voice, "Enough!"

Welles rushes toward the enticing "ladies of the evening" and scooping Jean up in his arms he heads for the master bedroom with Marlene and Greta bouncing and giggling closely behind. The massive bedroom door slams shut, leaving Toland standing there alone in the middle of the suite, still holding the 75mm lens and surrounded by all the equipment.

"School's out, I take it," he muses to himself. Then Gregg smiles a wry smile as he imagines all of the possibilities available to the Boy Wonder on the king-sized bed in the Presidential Suite. He carefully puts away the 75mm lens and like a good teacher erases the blackboard. Finally, he glances at his watch; 3:45 A.M., before kicking off his shoes, curling up on the overstuffed sofa, and closing his eyes.

PINK'S HOT DOG STAND

ACT III
LET THERE BE LIGHT

Paul Pink was an entrepreneur. He opened his hot dog stand in 1939 next to the gas station among the weeds and rolling hills near the corner of Melrose and La Brea Avenues in Hollywood. It would be nearly seven more years before he traded in his famous hot dog wagon for a small building standing on the very same spot, yet somehow only months after he had opened, Orson Welles happened to discover this culinary delight and it soon became one of the Boy Wonder's favorite haunts.

Perhaps it was the sign that read "Curb Service" that had attracted him — that way Mr. Welles could wait in his Bentley while his studio driver Ernesto stopped in front and held up six fingers. Paul Pink would then quickly bring a half dozen of the chili dogs to Mr. Welles's car where he would ravenously devour every one of them.

Orson adored these simple, right-off-the-street hot dogs and Paul would always make sure they all had extra warm buns, were slathered with mustard, heaped with onions, and topped off with plenty of his soon-to-be-famous thick brown chili. But basically, you just couldn't beat the price, all six of them only cost sixty cents. That's right, just ten cents each. Of course, Orson would always leave a generous five-dollar tip for Paul, which insured that whenever his Bentley appeared on the horizon, Mr. Pink would start making extra chili dogs.

Mr. Welles wasn't the only celebrity who loved Pink's delicious hot dogs and many stars of the day could be spotted lurking in the back of their limousines while their assistants, managers, gofers, drivers or chauffeurs brought them the sinfully delectable dogs. The likes of Will Rogers, Clark Gable, Errol Flynn, Lew Ayres, Clara Bow, Gloria Swanson, and even Bette Davis were rumored to have been seen in the vicinity of Melrose and La Brea Avenues.

"I'm starving!" Orson had bellowed in his best Lamont Cranston radio voice at 10:30 in the morning. Toland had sat bolt upright on the sofa as though God Himself had just doused him with ice water. "Sweet Jesus" he muttered to himself as he quickly realized that last night was not a dream. He had actually sat cross legged on the bar at the Brown Derby tossing ice cubes at a starlet's cleavage, he had actually relieved himself in the phone booth at Musso & Frank, he had actually been kissed by drag queens at the Roosevelt Hotel, and finally, he had actually taught the Boy Wonder himself, Orson Welles, the "Toes, T%&t, T#ts, Teeth" rule, with three call girls who all looked like

STARS ADORING HOT DOGS

famous movie stars, in the Presidential Suite at the Beverly Hills Hotel. "What in the name of Will H. Hays," Toland mused to himself, "is going to happen today?"

"I'm absolutely famished!" Orson boomed, taking Toland by the arm and leaving the ladies Marlene, Greta, and Jean lounging debauched in the bedroom in various stages of undress on the king-sized bed. He hustled Toland out of the massive door to the Presidential Suite down the darkened hallway, through the opulent lobby out the ornate front door past the immaculately dressed doorman, "Good morning, Mr. Welles." "Good morning, Wallace," and into the waiting Bentley. Then Orson only said just one word to Ernesto: "Pink's!"

Orson and Toland ate their fill of these amazing hot dogs, which somehow always seemed to taste even better on an empty stomach or after a night of reveling. They washed them down with chilled imported Irish whiskey and soda, which Orson always had Ernesto keep on hand in the Bentley for just such an occasion or as an eye opener on those usual mornings after.

Back in the day most of the guys in Hollywood were serious drinkers and functioning alcoholics for one reason and one reason only, because they could be. However, it wasn't really that different from today or perhaps anytime. Whenever any celebrity, whether in politics, religion, business, sports or showbiz, has been paid a ridiculous amount of money and surrounded by groups of fans, friends, followers, worshipers, and hangers on, who reinforce their status as the be all and end all authority or awe-inspiring leader — those very same celebrities have on occasion abused that power and privilege by

over-indulging in whatever they choose. Be it drink, drugs, food, nightlife, sex, shopping for that next totally unneeded and very unnecessary luxury item, or simply not bothering to put on underwear.

Back in the Presidential Suite surrounded by all the film equipment, with the drapes drawn shut against the dreaded glaring sunlight, Mr. Welles soon insists that Toland carry on with his instruction. Welles assures him that he had understood that the camera and lenses were the "Holy Vessel" by which the "Eucharist" of the film was transported and exposed and that those very same lenses were used to do various "shots." Wide shots, medium shots, close shots, and very close shots that were needed to visually tell the story and to enable the motion picture to be edited together and ultimately exhibited.

"*Alora, Professore Toland, que cazzo fai?*" Welles inquires as he freshens up their cups of Irish coffee with additional splashes of imported Irish whiskey. Toland sips this elixir and looks around the equipment-laden room as though something were once again missing. Finally he turns to Orson and simply states "Stand in." Welles smiles, nods and proceeds to pick up the phone; when Madam Gaylord eventually comes on the line, Welles says only two words to her, "Surprise me!"

Cut To:

Several minutes later when they hear the inevitable knock, Orson eagerly opens the massive door to the Presidential Suite. There, dressed in a man's beige double-breasted

business suit, stands Katherine Hepburn. Or rather an expensive call girl who looks very much like Miss Hepburn. Orson is fascinated by the uncanny resemblance and he turns the young lady around several times admiring her sensual beauty and appreciating the full effect of her dazzling presence.

Toland has already placed on a pair of work gloves, located the power cables for his lights and has plugged several of them in, but he has not as yet turned the lights on. Now, he asks Mr. Welles to kindly escort the lovely Miss Hepburn over to a straight-backed chair that he has placed by the drape-drawn windows. When that's done Toland proclaims, "Let there be light!" as he dramatically opens the drapes and lets the harsh sunlight strike the surrogate Miss Hepburn's young, unblemished face.

Toland understood that Orson knew something about "lighting" and setting the "mood" since he had come out of the theater. "However," he opined, "movies are dealing with photographic lighting, and the mood and effects that Cinematographer's are called upon to create are infinitely more subtle and much more critical, since they create an emotional response in the audience." Toland continued by explaining that, since movies were often shot on "location" they were constantly dealing with "natural light," which was the harsh source that was presently illuminating Miss Hepburn. Toland then took one of the three-foot-by-three-foot silks and held it up between the window and Miss Hepburn. The effect was startling as the silk immediately turned the harsh, hard light into a softer light source that seemed to surround Miss Hepburn's lovely face.

KATE'S FACE IN HARSH BACK LIGHT

KATE'S FACE IN HARSH BACKLIGHT, WITH FILL

Toland then politely requested that Miss Hepburn kindly turn her chair with its back to the window. When she did so and sat back down, they both could see that her face was now nearly hidden in deep shadow, while her hair was being hit by the very strong "backlight." Toland adeptly took a small reflector and placed it so that the "soft side" was facing Miss Hepburn and was reflecting the natural light back onto her face.

The reflector produced a lovely glowing light and Toland explained that whenever the studio shot on location, they always attempted to place the actors in a complimentary "backlight" and then filled in the shadows with reflectors or incandescent lights. Or, they would simply shoot all of the long shots of the scene in natural light and then use a large silk to make the light softer and more pleasing when they moved in to shoot the medium shots and close shots.

Then, with a flourish, Toland closed the drapes and once again engulfed the room in deep shadows. Presently, he turned on a junior 2K light and pointed it at Miss Hepburn. In addition to "natural light," he explained, the Cinematographer is also constantly dealing with "unnatural light" every day in the studio. This incandescent source was also harsh on Miss Hepburn, as Toland first demonstrated for Welles the "spot" and "flood" functions of the light. By turning the knob on the back of the unit he "flooded" the harsh light out, making it softer and more pleasing to the eye.

Then he showed Welles how to soften it even further, by using the diffusion rings that were in a container on the light's stand. He placed the "half" and "single" and

"double" diffusion rings into their slots in the light's "barn doors," demonstrating their function. Finally he showed the Boy Wonder how to adjust the "barn doors," cutting the light off of the foreground and background, so that it was only illuminating the right side of the lovely Miss Hepburn's head and shoulders. Then he held up one finger and stated, "First, the key light."

Toland then moved a baby 1K light behind Miss Hepburn in opposition to the key light, turned it on and repeated his lighting adjustments so that this unit was illuminating the back of her head and shoulders. Then he held up two fingers and stated, "Second, the kicker." Finally, Toland took a small inky 150W light, turned it on and once again made his adjustments, then moved it so that this unit's light was filling in the shadows on the left side of Miss Hepburn's face. Then he held up three fingers and stated, "Third, the fill light."

Toland continued by explaining that the accepted way that every Director of Photography lit every actor and every actress and every object in every studio on every set in front of every camera, was exactly this way with a "key light," a "kick light," and a "fill light." Or, he opined, a daring Director of Photography such as himself could also experiment with the areas of light and shadow by using only one or two of these lights to achieve a much more dramatic or eerie effect. Or you could break the rules altogether, as he had done for *The Grapes of Wrath*, to simulate candlelight. After providing a "base exposure" in the Joads' deserted cabin that was nearly two stops underexposed, he used only a small bright light behind a hollowed-out candle held in the actor Henry Fonda's

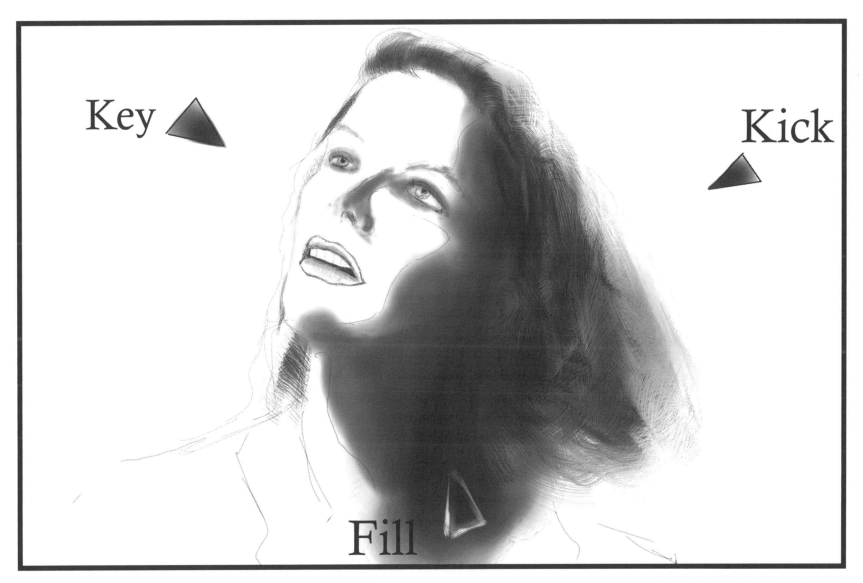

KATE'S FACE, WITH "KEY, KICK, AND FILL" LIGHT DESIGNATED

hands with the electric cable running up the actor's sleeves and down his pants leg to provide power. "That," Mr. Welles concluded, "deserves a refill!" And the Irish whiskey continued to flow.

Now, for dramatic effect, Toland turned out all of the lights and again plunged the room into darkness. He took the Inky light off its stand, turned it on and using the small silk he bounced the light off of its white surface onto Miss Hepburn's face. "There are of course infinite variations on this theme of lighting. You can literally become obsessed with the subjects of light and shadow, not to mention color, which will soon be raising its ugly head." Toland opined to the Boy Wonder, "but your decisions and choices should always be dictated by what's necessary to set the mood for each particular scene and the overall visual theme of the script."

Toland paused, "Finally, there are basically only six positions to choose from when placing a light on a subject." He laid the silk down and moved around Miss Hepburn, illuminating her from various sides as he dramatically showed Welles what he meant by the six positions: "One, above; two, below; three, left; four, right; five, front; and six, back. To begin to light any scene, what you need to do first, is to determine where the light is coming from."

Then Toland placed the inky light back on its stand and picked up his trusty Norwood light meter. The four-inch 100mm lens was still on his Mitchell BNC camera and Toland asked Orson to line up a nice "teeth" shot of Miss Hepburn. Orson dutifully unlocked the wheels on the geared head, then panned and tilted the camera until he had

ABOVE

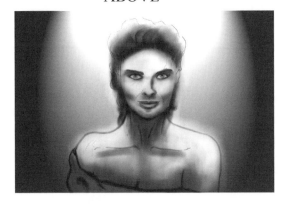

BELOW

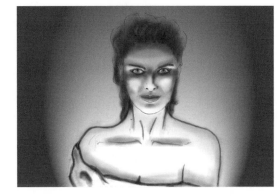

FRONT

LEFT

RIGHT

BACK

KATE'S FACE ILLUMINATED, ABOVE, BELOW, LEFT, RIGHT, FRONT, BACK

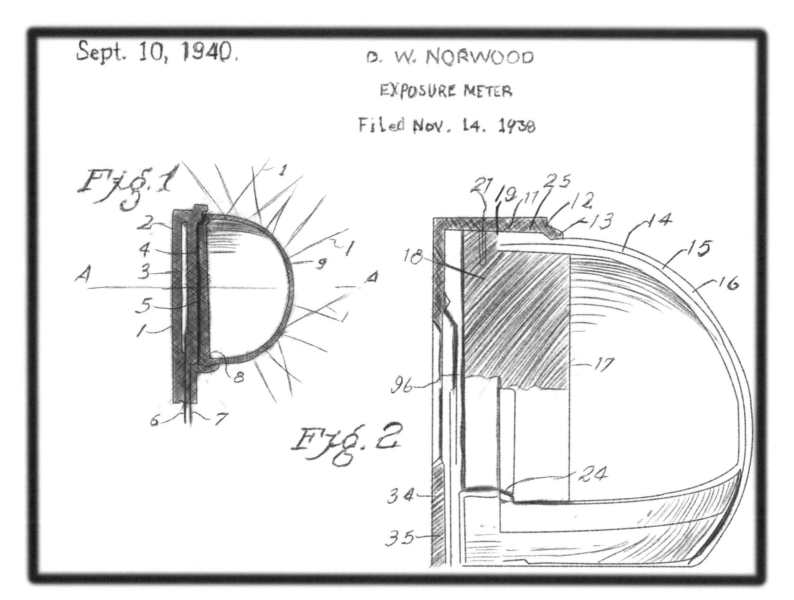

Sept. 10, 1940.

D. W. NORWOOD

EXPOSURE METER

Filed Nov. 14. 1938

Fig.1

Fig.2

DONALD W. NORWOOD EXPOSURE METER

a very close shot of the pseudo–Miss Hepburn. Then Toland showed Welles the light meter, explaining to him that Donald W. Norwood had invented it in 1938 and as yet didn't have the patent, but since he was Gregg Toland….

He showed Orson how it read the amount of light being thrown onto a subject, either by the natural light of the sun or the unnatural light of the studio lights, and that the numbers on the meter corresponded to the f-stop settings on the lens. He pointed out the f-stops on the 100mm lens and explained that each succeeding f-stop — 2.8, 4, 5.6, 8, 11, 16, and 22 — allowed exactly half as much light to enter the lens as the previous f-stop. He then showed Orson how to set the meter for the sensitivity of the film, first explaining that the ASA or American Standards Association, who would set each film's sensitivity to light, would be releasing their findings in several years, but since he was Gregg Toland….

He stated that the film's speed was determined by multiples of 8 and the most popular films of the day were ASA 16 or 32, but Eastman Double-X was an exceptional ASA 64 and the more experimental emulsions were being tested at ASA 100 or more. Then he asked Orson to read the light that was falling onto Miss Hepburn, by taking the light meter over by their lovely stand in, holding it in front of her face toward the light source and seeing where the needle on the front of the meter stopped. Orson followed his instructions perfectly, then stated that the needle was between the 2.8 and the 4.

MITCHELL LENS CLEARLY SHOWING "F-STOPS"

Toland asked Orson to come back to the camera and find the right setting on the lens for this scene so that their costly, precious, and irreplaceable film would be properly exposed. Orson quickly moved back to the lens, observed the ring on its barrel containing the various f-stops, and saw that touching the ring there was a small white line. The white line was now opposite the setting 5.6 and Orson turned the f-stop ring until the white line was touching between the 2.8 and the 4.

Toland nodded his approval, declaring that Mr. Welles was indeed the "Boy Wonder," had an extremely large IQ, and was an exceedingly quick study. Toland continued by saying that the Director of Photography could choose the proper exposure for each scene by reading either the sun or the key light and then, if the information in the shadows was too dark, more fill light would need to be added. However, if you were shooting in the forest or predominately in the shade, then you would set the exposure for the shadows and let the areas of sunlight "burn out."

"Enough," boomed Welles in his best Opening Night on Broadway voice. It seemed that he'd finally had his fill of moviemaking instruction for the day and he quickly began to lavish his ample affections on the lovely Miss Hepburn look-alike. Toland knew that school was officially over and he methodically began wrapping the equipment.

"I'm f#*king Hepburn. Who do you want?" Welles interjected. Toland thought for a moment as he took off his work gloves, then replied, "Harlow." "Perfect," the Boy Wonder snorted between nibbles on Miss Hepburn's lovely neck, "I'll call Gaylord — afterwards we're going gambling."

SIGN/SANTA MONICA ROUTE 66 END OF THE TRAIL

ACT IV
OBJECTS AT REST OR IN MOTION

The idyllic beachfront community of Santa Monica was incorporated in 1886 and named for Saint Monica, the mother of Saint Augustine. However, by 1922 the tranquility and "saintliness" had begun to wane since various Hollywood celebrities had already started buying up the surrounding land. Will Rogers owned an immense ranch in Santa Monica Canyon and by 1928 he had sold his sizable property on the beach containing two houses to the infamous William Randolph Hearst, who of course had passed it on to his mistress

Marion Davies. Other notable celebrities to have established homes in the seaside community during that time were Greta Garbo, Cary Grant, and Douglas Fairbanks..

In 1928 gambling ships had also begun anchoring just beyond the three-mile limit off the coast in Santa Monica Bay. They would ferry their high-rolling customers in search of illicit pleasures to and from their dens of iniquity via speed boats that left from the darkened rendezvous spots that had sprung up along the various piers between the communities of Venice and Santa Monica.

Of course, organized crime, graft, bribery, corruption, political payoffs, and other unpleasantness also seemed to find its way to Santa Monica along with the gambling, alcohol, drugs, and prostitution. But the then–Attorney General of California, the Honorable Earl Warren, was planning his own agenda for these morally offensive and illegal operations.

On the way to the beach Orson recalled the Pink's chili dogs earlier in the day and how Paul Pink had once told him that he used bacon drippings as a key ingredient for his chili. Now that thought was causing Mr. Welles to think about pork, lots of freshly roasted pork. Toland suggested that they go out for some ribs and volunteered that he knew a great spot. Instead Orson had Ernesto pull the Bentley up by a pay phone and he immediately called the head chef at the Beverly Hills Hotel, telling him that he wanted to roast a pig, an entire pig! Toland just stared in disbelief as Welles also told the culinary master not to use the ovens in the kitchen but instead to roast "his pig" over an open fire in the barbeque pit behind the bungalows! Nothing it seems exceeds like excess.

OIL RIGS CLOG THE VENICE COASTLINE

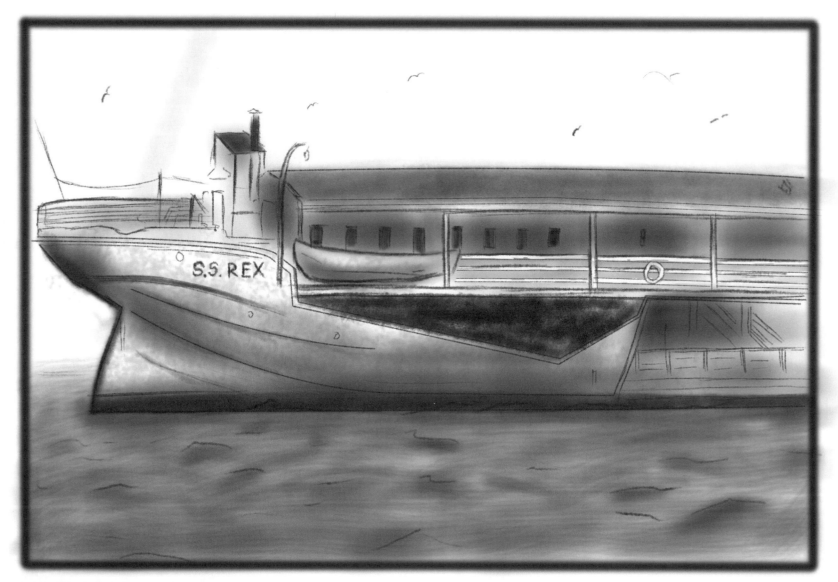

GAMBLING SHIP S.S. *REX*

It was magic hour, that most beautiful time of the day, when the Bentley arrived near the pier in Venice. Orson asked Ernesto to wait while he and Toland took one of the speedboats out to the newest, biggest, and most fantastic of all the gambling ships, the *S.S. Rex*. As their speedboat veered away from the coastline and shuttled them out toward the gathering darkness of Santa Monica Bay, Orson curiously regarded all of the immense oil rigs that were clogging the Venice coastline, pumping their black gold, and speculated to Toland, "Wouldn't that make a great location for a movie?" Toland nodded in agreement and they both shared a toast of imported Irish whiskey from their flasks.

Tony C. was connected. He and his "friends" in Chicago had a vested interest in all of the gambling ships that were anchored offshore in Santa Monica Bay. The big bucks in Hollywood had attracted gambling and all of its ancillary vices and this venture had proven itself to be a veritable license to print money for these characters of ill repute. Since all of their enterprises, the gambling, the alcohol, the drugs, and the prostitution were a "cash only" proposition they raked in millions of tax-free dollars. After all, who was looking over their shoulders? Absolutely nobody! Who would dare to check their books, the IRS? Forget about it!

The *S.S. Rex* didn't have and didn't need a motor; it wasn't going anywhere. Tony C. had built his pride and joy from scratch all offshore — it was the apple of his eye and an absolute top of the line, state-of-the-gambling-art beauty. It was big, opulent, and could hold upwards of three thousand high-rolling, liquor-swilling, fornicating gamblers

at a time. All day and all night, every day of the year, year after year after year, and remember the odds were always in favor of the house, or in this case, the ship. This was not only a floating crap game; this was to Tony C. and his "friends" a floating gold mine.

Tony C. didn't give a rat's ass about Orson Welles or the movies, but he did give a rat's ass about Mr. Welles's money and the money of all his big, well-paid, influential, show business pals who might also come to the *S.S. Rex* to try their luck. Which, as Tony C. and all the ship owners knew, would mostly be bad. Tony C. smiled broadly, gave Orson a big hug and called him "Maestro," then invited him and his guest to play roulette or blackjack or craps in the comfort of his private V.I.P. Suite away from the hustle and bustle of the main room, which always seemed to be awash with the din of the gambling riff-raff.

As Tony C. led them toward the private V.I.P. Suite, Orson introduced his Academy Award–winning Cinematographer friend Gregg Toland. Tony showed just the right amount of deference and respect to Mr. Toland, since he had not actually encountered that many Academy Award winners aboard his luxurious floating casino. Then before leaving them to throw away their money, on what he and his "friends" laughingly referred to as "games of chance," Tony gave both Gregg and Orson his special business cards with a confidential number to call, in case they would ever like Tony C. to send his own private luxury speed boat "da fasted f#★kin' vessel in da watta," to pick them up and bring them to the *S.S. Rex* any time — twenty-four-hours a day.

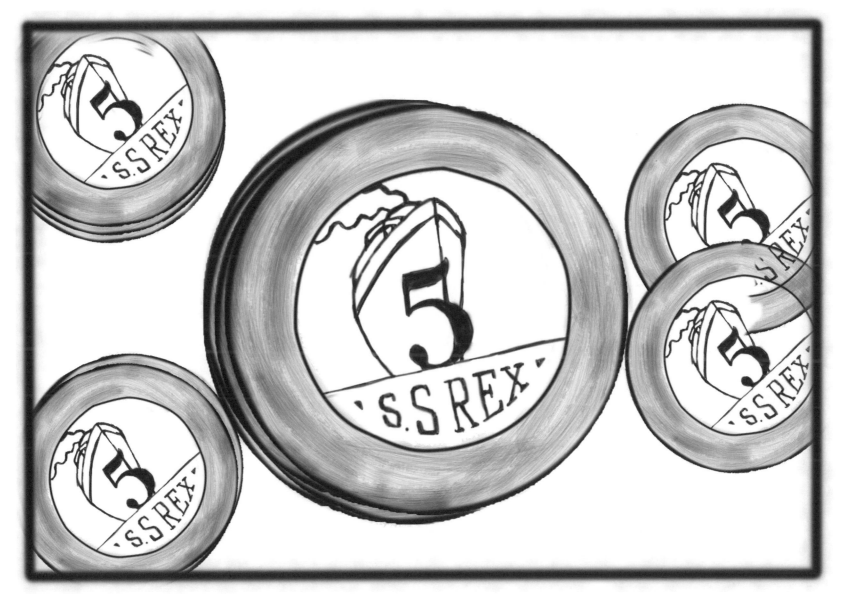

S.S. *REX* POKER CHIP

"TOMMY" GUN

Toland and Welles both appreciated the relative quiet and exclusivity of the V.I.P. Suite as Orson bought several hundred dollars worth of chips, which he was just about to wager at the roulette table when there was the sound of gunfire from somewhere outside. Many of the high-rolling patrons, along with Toland and Welles, rushed out of the V.I.P. Suite through the casino and out onto the main deck of the *S.S. Rex*. Everyone, the high rollers and the riff-raff alike, were stunned to see that half a dozen police boats with their spotlights shining onto the floating casino were standing between the vessel and the safety of the Santa Monica shoreline.

Presently a uniformed police officer hoisted his megaphone and proclaimed to all onboard that the Attorney General of California, the Honorable Earl Warren, had a court order to shut this establishment down. That he, in the name of the Attorney General, also commanded that the captain and his crew surrender their ship to the authorities immediately or face dire consequences.

Of course, Tony C. and his men didn't see it that way. They believed that they were technically in "innanashanal wattas" and as Tony told his men, "Oil Warrn can go f#★k 'mself!" He then passed out the machine guns, telling the henchmen not to hit any cops, just to fire into the air to show them that they had firepower. Then to spray "da screws" with the ships water cannons.

Tony C.'s thugs quickly spread out along the main deck and let fly with their tommy guns, sending bullets and shards of muzzle flashes into the dark night sky.

Immediately all of the patrons began to scatter like so many rats hoping to leave a sinking ship, as Tony C.'s men began dousing the nearest police boats with the ship's water cannons. That's pretty much how it went down, "The Battle of Santa Monica Bay" had begun, Earl Warren had basically fired the first shot across the bow of the *S.S. Rex* and Tony C. had responded with his fusillade.

Mr. Welles and Mr. Toland both understood that they could not and must not be caught in the middle of this extremely messy situation that would most certainly also turn into a highly publicized one. They immediately cornered Tony C. and requested that he kindly send them back to port, as quickly as possible, on his private speedboat. Tony C. smiled, "Sure," he answered, "da fastest f#★kin' vessel in da watta — be my pleasure."

Tony C. was more than happy to escort the exclusive guests to his vessel. He hustled them quickly and quietly on board along with a certain United States Senator, two Congressmen, the vice president of Standard Oil, and an assortment of Tony's favorite call girls, including a transvestite with five o'clock shadow, dolled up to look like Aimee Semple McPherson.

Tony C. lit up a Cuban cigar and shouted after his speedboat as it sped away into the darkness, "Dis 'll all be ova in a coupla owas." Actually, it took nine days for the *S.S. Rex* to surrender and that was the final curtain for any offshore gambling in the Santa Monica Bay. However, it was not the final curtain for Tony C. and his "friends" from Chicago, whose next stop was Las Vegas. There he would erect an enduring monument for all future gambling clientele to tell their grandchildren about: the Stardust Casino.

GUY DRESSED AS AIMEE SEMPLE MCPHERSON

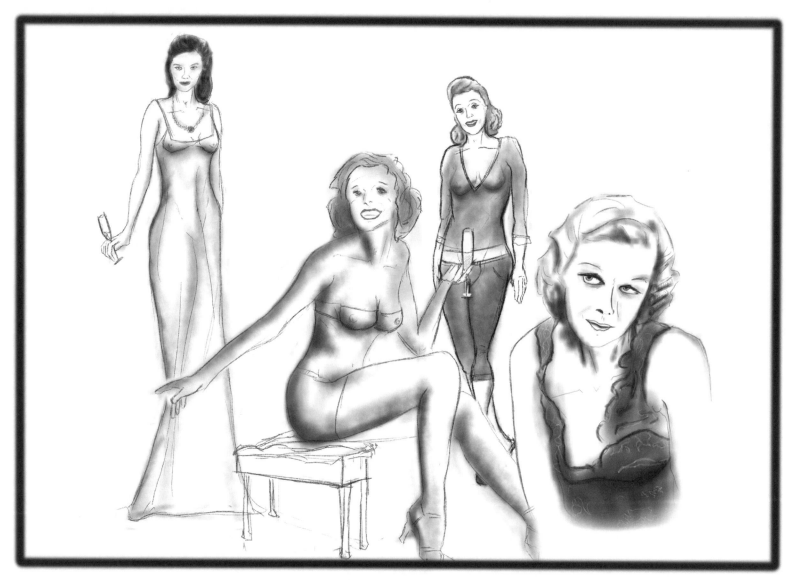

LOOK ALIKE CELEBRITIES OF THE 1920S AND 1930S

Back in the secure and opulent confines of the Beverly Hills Hotel, music from a portable record player filled the night air with the mellow sounds of Tommy Dorsey, as huge slabs of pork from the fatted and open-pit-fire-roasted pig, were now being served up by the head chef to Welles and Toland. They both enjoy a good laugh recalling their exploits aboard the *S.S. Rex* as they pass yet another bottle of imported Irish whiskey between them.

Apparently Orson has also invited Madam Gaylord and her harem of delectable call girls to the party and the ladies of the night are enjoying a case of champagne along with the tasty meal. This cloistered affair had the same ambiance as many of the "after parties" at the Academy Awards or other tinsel town gatherings, as Welles and Toland mingled with the Madam and the Hollywood look-alikes of Garbo, Harlow, Dietrich, Hepburn, as well as other stars of the current and the silent screen.

Satiated and stimulated by the food, drink, and music, "Harlow" began to do a sensual strip tease as everyone eagerly gathered around her, clapping in unison and encouraging her erotic performance. Madam Gaylord, who had always looked down on such a "vulgar display," moved purposefully through the throng and politely pushed her lovely hireling into the pool, simply to cool her off. Then "Hepburn" playfully pushed Orson into the pool, and as "Harlow" began to wrap her wet, glistening naked body around him and tear at his clothes, the rest of the look-alike revelers felt that they might as well join in the festivities. Before you could say "orgy" the entire after-hours

party, Toland included, was in the pool, playing and kissing and groping and thrusting and leaving only Madam Gaylord and the head chef ambivalently sneaking glances at the erotic display and sipping their champagne.

Fade Out:/Fade In:

Next morning in the Presidential Suite, Orson drops a little white pill into Toland's open, eager and slightly trembling hand, then pops one himself. They both wash it down with fresh black coffee that has just a taste of Irish whiskey in it to act as the "hair of the dog" that they both so desperately need. They munch on a cart overflowing with fresh fruit and sweet rolls, as Orson inquires, "Okay, Gregg, the camera, the film, the lenses, the shots, the light — what's next?"

Toland goes to the blackboard and begins to draw as he replies, "blocking, coverage, continuity, and movement." Orson adds another taste of Irish whiskey to his cup of coffee and pops a strawberry into his mouth as Toland begins his lecture.

Toland has drawn the top view of a football field with teams "A" and "B" playing on it as well as the top view of a table with persons "A" and "B" sitting across from each other. Then he explains that whether you are filming something as large as a football game or as intimate as two people having a conversation, there is a "180-degree rule" that applies in order to keep the continuity consistent and to keep the audience from ever getting lost.

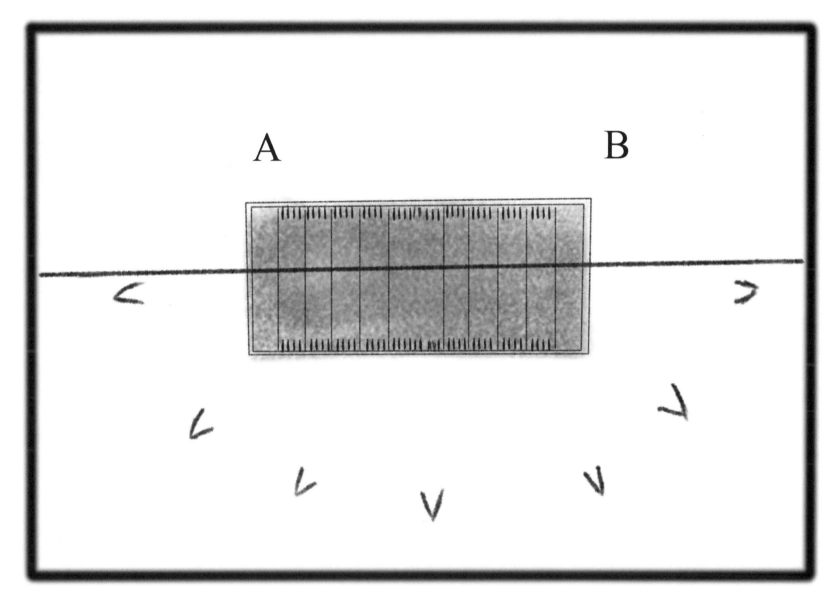

FOOTBALL FIELD, TEAMS "A" AND "B" CAMERA POSITIONS

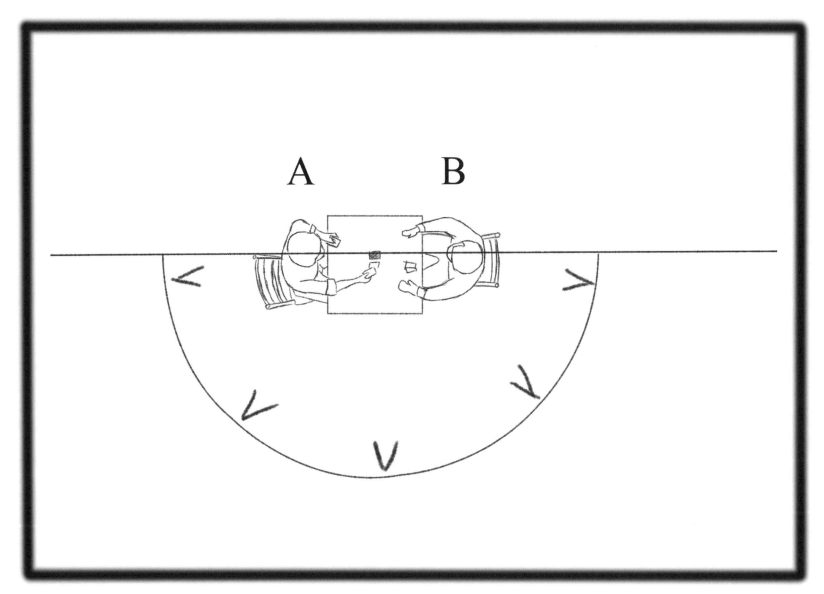

COUPLE "A" AND "B" AT TABLE, CAMERA POSITIONS

He continues by drawing a line from left to right through the center of the football field and through the center of the people and the table. Then he begins to add a series of V's that represent camera positions from just below the "line" on the left side, all the way around in a 180-degree arc to just below the "line" on the right side.

"That's all there is to it," Toland states, "no matter where the teams go on the field, the camera never crosses that imaginary line and everyone knows exactly where they are." Toland goes on to explain that he knows Orson understands how to "stage" a scene from directing theater. However, all that theater basically is, is a two-hour master shot and in order to "edit" a scene, any scene, so that it works in a motion picture you must have "coverage," which means closer and more detailed shots besides the "master" to make it work.

"Toes, T%&t, T#ts, Teeth," Orson interjects. "More or less," Toland replies, "but look carefully at this — this is what is meant by classic coverage of any scene."

Toland then begins to draw a rough series of "storyboards" of the two people, "A" and "B," sitting at the table. He first sketches a very wide "master shot" of the entire room full of tables. Then a closer "two shot" of our couple "A" and "B" holding up their wine glasses, sitting at the table with person "A" on the left side and person "B" on the right side of the table and frame.

That's followed by an "over the left shoulder shot" of person "B" on the right side of the table and frame, toward person "A" on the left side of the table and frame. Followed by a "close-up" of person "A" looking right toward person "B." Then he draws

an "over the right shoulder shot" of person "A" on the left side of the table and frame toward person "B" on the right side of the table and frame. Followed by a "close-up" of person "B" looking left toward person "A." Finally, he draws and labels the "close-up" of the two wine glasses as an "insert."

Toland continues by explaining to Welles that "continuity" is also a vital part of the shots and the coverage for any scene. He points out that "continuity" is achieved mainly during the editing of the scenes, but that the Director of Photography can immeasurably assist in the process by making sure that a few key elements are taken care of during the shooting.

First, Toland continues, whenever they change the camera angle or a lens to do additional coverage, they always move the camera about 30 degrees, which will help to make the transition from shot to shot smoother. Second, if our couple "A" and "B" are sitting down at their table, pouring wine and toasting each other in the master, then when we do our medium and close shots we must make sure that they "repeat" their actions exactly, every time. This "overlapping" of their actions will also assist in making the editing transitions from shot to shot smoother.

Third, Toland explains whenever it's possible always try to get a "clean entrance and clean exit." Which means that whether it's a person, a car, a train, or a tumbleweed, try to start on a static frame with a pleasing composition. Then allow the action or the person to enter, follow it along smoothly and always leave more room in the frame in

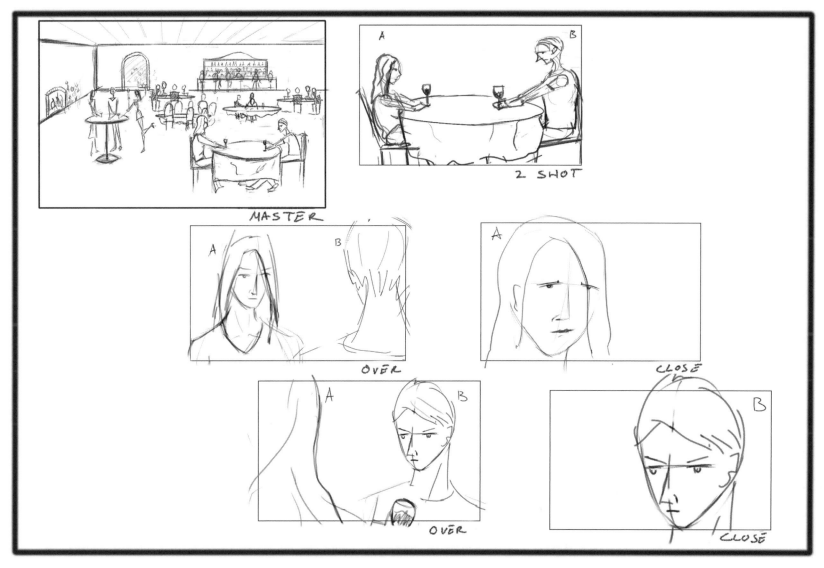

STORYBOARD SKETCHES OF COVERAGE

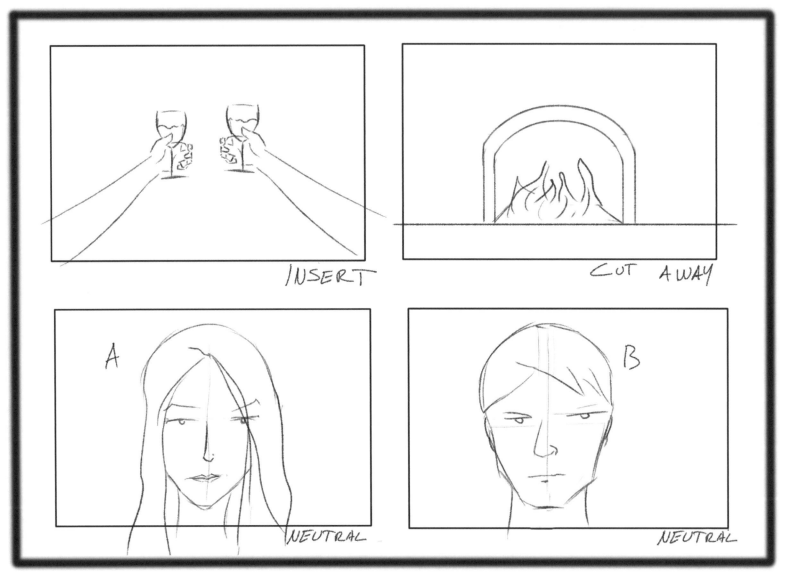

STORYBOARD SKETCHES OF AN "INSERT," "CUT AWAY," AND "NEUTRAL ANGLE"

whatever direction the action is moving. Finally, let the action or person exit and finish on another static frame.

Toland explains that often due to scheduling changes, scenes get shot out of order, piecemeal, and sometimes do not get finished until days or even weeks later. That fact makes it very easy for mistakes to be made in the continuity. The answer to that problem is simple — Toland points to the "insert" of the couple's wine glasses and then sketches two more "storyboards" as he further explains that the Director of Photography should always insist that an "insert," a "cut away," or a "neutral angle" is shot for every scene.

The "insert" will help with any continuity problems as will a "cut away," which is a shot of another couple eating, or the musicians playing or the fire in the fireplace. Finally, a simple "neutral angle," which is one or both of the actors looking directly into the camera, will also solve most continuity problems or an inadvertent "crossing of the 180-degree line."

Orson thoughtfully nods, having absorbed all of the "classic coverage" and "continuity" points that Toland has made. Presently he states, "However, I can move the camera so that the 'master shot' becomes the 'two shot' and the 'over the shoulder shot' and even the 'close-up,' which will also take care of any 'continuity' problems, correct?" Toland simply tosses the chalk into the air, rolls his eyes and nods "yes," then shakes his head and gives Orson a look like, "Why am I even attempting to teach the Master?"

Orson continues by pointedly asking, "Gregg, is there also a way that I can stage a scene with three characters — where one character is in focus in 'close-up' in

the foreground of the frame, another character is in focus in a 'medium shot' in the middle of the frame, and a third character in focus in a 'wide shot' in the background — all in the same shot?"

Toland smiled to himself since he had already been perfecting this "deep focus" technique on several of his previous productions, the most notable being the John Ford film *The Long Voyage Home*. Nevertheless, he played the moment by pacing around and pondering for a few beats, as though Orson might have stumped him. Then he stopped, purposefully turned to Orson and told him that by using the combination of the new fast film, a wide-angle lens, and a large amount of light, he could accomplish the shot that the Boy Wonder had requested.

Orson beams with delight, then bellows, "So much for 'blocking and coverage and continuity,' what about 'movement'?" Toland explained to Welles that with the crane, the dolly, and the track they could basically put the camera anywhere in any scene that the director could imagine or dream up. It can start up high and crane down low, or start far back and dolly in close, or the reverse. Or, it can track with the actors right to left or left to right, and if the crane isn't high enough, Toland continues, we can build scaffolding and place the camera up as high as you want it to go.

Toland went on to say that there was a very talented gentleman in the Art Department, Perry Ferguson, who had worked on *Alice Adams*, *Bringing up Baby*, and *Gunga Din*, who would be a great help to Orson in realizing the overall production design and that Linwood Dunn, who had worked on *King Kong*, and Vernon Walker,

who had worked on *The Hunchback of Notre Dame*, were the special effects geniuses at RKO who could do amazing things with their "optical printer." They could virtually take the camera anywhere — even through walls!

Toland also told Orson about a small "handheld" camera called the Eymo, which was first manufactured in 1925. He stated that it only took a small 100-foot roll of film, but that it could enable you to get into some very tight places. He had actually experimented by carrying it around by hand in a boxing ring to follow the fighters and he was already working on his own version of it for the military that would incorporate the patented Mitchell movement.

"How low can we place the camera?" Orson then pointedly asked. "Well," Toland replied, "we are limited by the floor of the sound stage. If we were outside on location we could dig a hole in the ground." Orson smiles to himself, then suggests that they will either build their sets up on platforms higher than the floor of the stage, so that he can achieve the low angles of the actors that he must have, or that Toland and the crew should be prepared to dig a hole right there on the sound stage as well!

WELLES AND TOLAND AND CAMERA IN STAGE FLOOR

ACT V
FRANKLY ORSON, I DON'T GIVE A DAMN

By now it's the middle of Sunday afternoon and Toland is feeling the effects of the long drug-and-alcohol-fueled weekend. All that he really wants to do right now is go home and attempt to sleep it off before he has to show up for work on Monday. However, when he makes that suggestion Orson insists that there must be "more to making the movies than just that? What about the all of the editing and the sound and the lab and all the rest of that — rigmarole?"

The Citizen Kane Crash Course in Cinematography | David Worth

91

"Sure, sure, sure," Toland replies, as he attempts to rub that numb pain out of his forehead with the fingers of his left hand. "There's a lot more to it, but at least you have the basics." He continues to explain that the editing can be as important as the photography, because it can either make or break your film. All you have before the film is edited, he continues, is a collection of the picture and sound material, the "shots." It has to be very carefully put together to correctly tell the story, determine the structure, rhythm and pace. "So," he concludes, "be sure when it comes to choosing an editor, that you get some young guy who's not set in his ways because these old editing f#★ks can be a real pain in the ass!"

Toland goes on to state that most editors are simply "technicians" who sit in a cool room all day and complain. He believes that they cannot put anything together that the Director and Director of Photography haven't given to them. "For example," he continues, "if a scene is done all in a moving master shot what can the editor do? However, if a scene is done with a master shot and a medium shot and a close shot, then the editor can put something together." Toland concluded that eventually it all has to be approved by the Director and then the Director has to answer to the Producer. Not, of course, in Mr. Welles' case since he has "final cut." "Just make sure," Toland advises the Boy Wonder, "that you're always there, never leave these editing f#★ks on their own or you'll be sorry."

OLD UPRIGHT CUTTER MOVIEOLA AND SOUND MIKE

PROSTHETIC MAKEUP

Toland throws back a couple of shots of imported Irish whiskey to help ease that pain in his forehead, and continues, "Of course, both the sound and the music are also very, very important, but Orson, you're a radio specialist — you understand better than anyone how to use sound and the impact that it has. I'm sure that you will drive the sound guys up the walls, but sound is sound. You'll make them do exactly what you want them to do and if they don't you'll just push them aside and show them how it's done."

"When it comes to the lab," Toland continues, "that's exactly where we will begin our collaboration, because I will need to shoot a lot of 'lab tests' to show you exactly what the lenses, and exposure, and focus will look like for certain scenes, as well as doing tests for the sets and the wardrobe and most especially for your makeup."

"After this whole elaborate production is completed," Toland continues, "there will be some kind of a premiere somewhere and everyone will be asking you all kinds of stupid and inane questions. I suggest that you go straight to the bar." Toland looks at Orson and wearily shakes his head, "Not that I ever have to lecture you about going to the bar."

Orson smirks as Toland comes over and looks at him man-to-man, straight in the eye. "Most importantly, Orson, whenever any technical questions come up during the production — and believe me they will come up everyday, often several times a day — you and I will always go off somewhere and discuss the matter in private. Never, ever in front of the rest of the cast or the crew."

Orson smiles and nods at Gregg, appreciating the intelligence and graciousness of this amazingly talented artist, then asks, "When do we start?" Toland smiles back and calmly states, "We already have. Let's meet in the commissary for lunch tomorrow around 1 P.M. and draw up a rough schedule."

With that Orson laughs out loud, grabs his new-found collaborator in a bear hug, and the two creative titans embrace and slap each other on the back. Then Orson holds Gregg at arm's length and proclaims, "It's still the weekend, Gregg, I'm thinking about flying down to Rosarito Beach for a sumptuous Mexican meal and some tasty Mexican "delicacies" for dessert. What do you think?"

Toland simply smiles at his new-found friend and Director, then winks and states, "Frankly, Orson, I don't give a damn. I'm probably only going to be able to survive one production with you, but I assure you it will be one amazing experience. I'll see you tomorrow in the commissary."

With that Orson and Gregg shake hands and Gregg heads for the door to the Presidential Suite. Just as he's about to exit, Orson calls after him and as Toland turns to face the man with whom he's about to make motion picture history, Mr. Welles smiles again, then simply and graciously states, "Thank you Gregg — and that first margarita this evening will be raised in your honor." Toland smiles his approval at Orson, nods and exits, quietly closing the door behind him and leaving the Boy Wonder, musing to himself.

Presently Orson picks up the phone and in his best Mercury Theater on the Air voice, bellows, "Get me the airport!"

And the rest, as they say — is history!

ORSON AND TOLAND AT WORK ON *CITIZEN KANE*

ORSON WELLES
Direction-Production

GREGG TOLAND, A.S.C.
Photography

SHARED TITLE CARD: WELLES/TOLAND

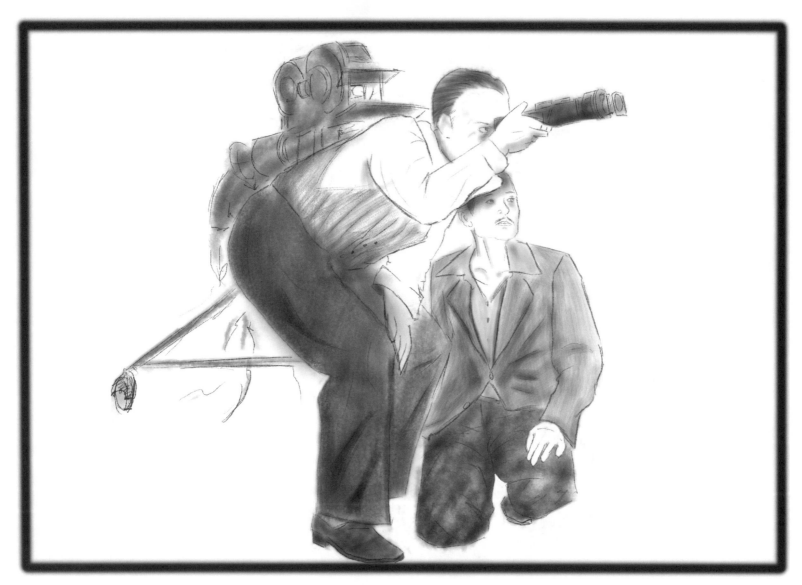

ORSON WITH MITCHELL VIEWFINDER, TOLAND KNEELING

DRAMATICALLY LIT SHOT FROM *CITIZEN KANE*

DRAMATICALLY LIT SHOT FROM *CITIZEN KANE*

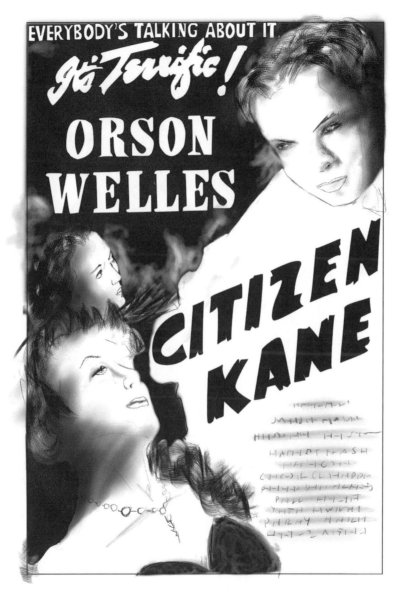

POSTER FROM *CITIZEN KANE*

ACT VI
AN APPENDIX

Cinematography: Cin-e-ma-TOG-ra-phy

McGraw-Hill Encyclopedia of Science & Technology:
"The process of producing the illusion of a moving picture. Cinematography includes two phases: the taking of the picture with a camera and the showing of the picture with a projector."

From *Encyclopedia Britannica*:
The "[a]rt and technology of motion-picture photography. It involves the composition of a scene, lighting of the set and actors, choices of cameras, camera angle, and integration of special effects to achieve the photographic images desired by the director. Cinematography focuses on relations between the individual shots and groups of shots that make up a scene

to produce the film's effect. Well-known cinematographers include Nestor Almendros, Gregg Toland, and Sven Nykvist."

From the American Society of Cinematographers (ASC):
"A creative and interpretive process that culminates in the authorship of an original work of art rather than the simple recording of a physical event. Cinematography is not a subcategory of photography. Rather, photography is but one craft that the cinematographer uses in addition to other physical, organizational, managerial, interpretive, and image-manipulating techniques to effect one coherent process."

CINEMATOGRAPHY IN OTHER LANGUAGES

Danish: Filmkunsten
Dutch: Cinematografie
French: Cinematographie
German: Kinematographie
Italian: Cinematografia
Russian: Knhematoraonr
Spanish: Arte Cimenatografico
Swedish: Filmonsten

THE CAMERA AND EARLY FILMS

The Columbia Encyclopedia, Sixth Edition. 2001–05

The original concept of the camera dated from Grecian times, when Aristotle referred to the principal of the **camera obscura** (Latin for dark chamber), which was literally a dark box — sometimes large enough for the viewer to stand on — with a small hole, or aperture, in one side. (A lens was not employed for focusing until the Middle Ages.) An inverted image of a scene was formed on an interior screen; it could be traced by an artist. The first diagram of a camera obscura appeared in a manuscript by Leonardo da Vinci in 1519, but he did not claim its invention.

The recording of a negative image on a light-sensitive material was first achieved by the Frenchman Joseph Necephore Niepce in 1826; he coated a piece of paper with asphalt and exposed it inside the camera obscura for eight hours. Although various kinds of devices for making pictures in rapid succession had been employed as early as the 1860s, the first practical motion picture camera — made feasible by the invention of the first flexible (paper base) films — was built in 1887 by E. J. Marey, a Frenchman. Two years later (1889) Thomas Edison invented the first commercially successful camera.

====

LENS APERTURE / F-STOP

F-Stops are the calibrations on the barrel of the lens that allow the cinematographer to adjust the aperture (iris) to allow the correct amount of light to enter the lens. On a normal lens the F-stops read from F2 (the widest aperture) all the way to F22 (the smallest). Each increment allows half as much light to enter through the aperture as the preceding one.

Standard Full-Stop F-number Scale, including Aperture Value (AV)

AV:	0	1	2	3	4	5	6	7	8	9	10
f/#:	1.0	1.4	2	2.8	4	5.6	8	11	16	22	32

The Citizen Kane Crash Course in Cinematography | David Worth

BIOGRAPHICAL NOTES

Orson Welles

The literature on the life and career of Orson Welles is extensive. As David Thomson comments in *A Biographical Dictionary of Film*, "But so little about the life and work of Welles is all or anywhere near true. He inhaled legend — and changed our air." Here are some basic facts:

Family background: Born May 6, 1915, in Kenosha, Wisconsin. Welles' father was a successful inventor and his mother a concert pianist. His mother died when he was nine; Orson then traveled the world with his father. After his father died when Welles was fifteen, Orson became a ward of Dr. Maurice Bernstein in Chicago.

Education: Graduated from the Todd School in Woodstock, Illinois in 1931. He turned down several college offers for a sketching tour of Ireland.

Early career: Recommendations by playwright Thornton Wilder and Alexander Woolcott got him into Katherine Cornell's road company, and Welles made his New York stage debut in 1934 at the age of nineteen.

He formed the Mercury Theater with producer John Houseman in 1937. In 1938 they produced "The Mercury Theater on the Air," famous for the broadcast version of *The War of the Worlds* that was only intended as a Halloween prank but created widespread panic at the time.

First feature film: *Citizen Kane* (1941). RKO lost $150,000 but the film has since been regarded by many as the best film ever made.

Welles had a long career as an actor and director, but much of his post–*Citizen Kane* career was characterized by half-completed projects and box-office failures. A major film, *Touch of Evil* (released in 1958), failed commercially in the United States but won a prize at the 1958 Brussels Worlds Fair.

In 1975, he received the American Film Institute's Lifetime Achievement Award, and in 1985 the Directors Guild of America awarded him its highest honor, the D. W. Griffith Award.

Orson Welles died in Hollywood on October 10, 1985 of a heart attack.

PERSONAL QUOTES

"I started at the top and worked down."

"I'm not bitter about Hollywood's treatment of me, but over its treatment of Griffith, Von Sternberg, Von Stroheim, Buster Keaton, and a hundred others."

"Movie directing is the perfect refuge for the mediocre."

"I hate television. I hate it as much as peanuts. But I can't stop eating peanuts."

"This is the biggest electric train set a boy ever had!"

"My doctor told me to stop having intimate dinners for four, unless there are three other people."

"Living in the lap of luxury isn't bad, except you never know when luxury is going to stand up."

"I have the terrible feeling that, because I'm wearing a white beard and am sitting in the back of the theater, you expect me to tell you the truth about something. These are the cheap seats, not Mount Sinai."

FILMOGRAPHY

1. *The Hearts of Age* (1934)

2. *Too Much Johnson* (1938)

3. *Citizen Kane* (1941)

4. *The Magnificent Ambersons* (1942)

5. *Journey Into Fear* (1943) — uncredited

6. *The Stranger* (1946)

7. *Lady from Shanghai* (1947)

8. *Macbeth* (1948)

9. *Black Magic* (1949) — uncredited

10. *Othello* (1952)

11. *Moby Dick Rehearsed* (1955) — TV

12. *Mr. Arkadin* (1955)

13. *The Orson Welles Sketchbook* (1955) — TV Series

14. *Around the World with Orson Welles* (1955) — TV Series

15. *Orson Welles and People* (1956) — TV

16. *Portrait of Gina* (1958) — TV

17. *Touch of Evil* (1958)

18. *The Fountain of Youth* (1958) — TV

19. *David and Goliath* (1960) — uncredited (his scenes)

20. *No Exit* (1962) — uncredited

21. *The Trial* (1962)

22. *In the Land of Don Quixote* (1964) — TV Series

23. *Chimes at Midnight* (1965)

24. *Vienna* (1968)

25. *The Immortal Story* (1968)

26. *The Merchant of Venice* (1969) — TV

27. *The Southern Star* (1969) — uncredited (opening scene)

28. *The Deep* (1970)

29. *The Golden Honeymoon* (1970)

30. *London* (1971)

31. *The Other Side of the Wind* (1972)

32. *F Is for Fake* (1974)

33. *Filming Othello* (1978)

34. *The Orson Welles Show* (1979) — TV (as G.O. Spelvin)

35. *Filming the Trial* (1981)

36. *The Spirit of Charles Lindberg* (1984)

37. *The Orson Welles Magic Show* (1985) — TV

====

Gregg Toland:

Gregg Toland was already a successful cinematographer when he met Orson Welles in 1940.

Family background: Born on May 29, 1904, in Charleston, Illinois, the only child of Jennie and Frank Toland. He and his mother moved to California several years after his parents divorced in 1910. His mother was a housekeeper for several people in the movie business.

Early career: By the age of fifteen, Gregg had a job as an office boy at William Fox Studios, making twelve dollars a week. Soon he was making eighteen dollars a week as an assistant cameraman. When sound arrived, the inventive Gregg helped devise a tool (a blimp), which helped to silence the noise from operating the camera. Toland became a camera assistant to George Barnes in 1926.

Growing success: Toland received his first solo credit as a director of photography on the Eddie Cantor musical *Palmy Days* in 1931. By 1939 he won the Academy Award, working with William Wyler on *Wuthering Heights*. He went on in 1940 to do groundbreaking work with John Ford on *The Grapes of Wrath* and *The Long Voyage Home*. That year he sought out Orson Welles, who then hired him to photograph *Citizen Kane*, which was released in 1941.

At the top of the heap: Toland soon became the highest paid cinematographer in the business, earning as much as $200,000 over a three-year period. In 1942 he co-designed the Cunningham Gun Camera, a 35mm magnesium alloy, four-lens turret camera for John Ford's troops in the Pacific during World War II. He became the first cinematographer to receive prominent billing in opening credits and did outstanding work in William Wyler's post–World War II drama, *The Best Years of Our Lives*, in 1946.

Toland died suddenly in 1948 at the age of 44.

Orson Welles on Gregg Toland

Welles said "that everything he knew about the art of photography a great cameraman, Gregg Toland, taught him in half an hour." Welles always paid Mr. Toland the ultimate compliment by saying, "Not only was he the greatest cameraman I ever worked with, he was also the fastest."

FILMOGRAPHY

1. *The Bat* (1926)

2. *The Winning of Barbara Worth* (1926)

3. *The Loves of Zorro* (1927)

4. *Johann the Coffin Maker* (1927)

5. *The Life and Death of a Hollywood Extra* (1928)

6. *Queen Kelly* (1929) — uncredited

7. *Bulldog Drummond* (1929)

8. *This Is Heaven* (1929)

9. *Condemned* (1929)

10. *The Trespasser* (1929)

11. *Raffles* (1930)

12. *Whoopee!* (1930)

13. *The Devil to Pay!* (1930)

14. *One Heavenly Night* (1931)

15. *Indiscreet* (1931)

16. *Street Scene* (1931)

17. *Palmy Days* (1931)

18. *The Unholy Garden* (1931) — uncredited

19. *Tonight or Never* (1931)

20. *Play Girl* (1932)

21. *Man Wanted* (1932)

22. *The Tenderfoot* (1932)

23. *Washington Masquerade* (1932)

24. *The Kid from Spain* (1932)

25. *The Nuisance* (1933)

26. *Tugboat Annie* (1933)

27. *The Masquerader* (1933)

28. *Roman Scandals* (1933)

29. *Nana* (1934)

30. *Lazy River* (1934)

31. *We Live Again* (1934)

32. *Forsaking All Others* (1934)

33. *The Wedding Night* (1935)

34. *Les Miserables* (1935)

35. *Public Hero #1* (1935)

36. *Mad Love* (1935)

37. *The Dark Angel* (1935)

38. *Splendor* (1935)

39. *Strike Me Pink* (1936) — dances

40. *These Three* (1936)

41. *The Road to Glory* (1936)

42. *Come and Get It* (1936)

43. *Beloved Enemy* (1936)

44. *History Is Made at Night* (1937) — uncredited

45. *Woman Chases Man* (1937)

46. *Dead End* (1937)

47. *The Goldwyn Follies* (1938)

48. *Kidnapped* (1938)

49. *The Cowboy and the Lady* (1938)

50. *Wuthering Heights* (1939)

51. *They Shall Have Music* (1939)

52. *Intermezzo: A Love Story* (1939)

53. *Raffles* (1939)

54. *The Grapes of Wrath* (1940)

55. *The Westerner* (1940)

56. *The Long Voyage Home* (1940)

57. *Citizen Kane* (1941)

58. *The Little Foxes* (1941)

59. *Ball of Fire* (1941)

60. *December 7th* (1943)

61. *The Outlaw* (1943)

62. *The Kid from Brooklyn* (1946)

63. *Song of the South* (1946)

64. *The Best Years of Our Lives* (1946)

65. *The Bishop's Wife* (1947)

66. *A Song Is Born* (1948)

67. *Enchantment* (1948)

OTHER SOURCE MATERIAL

http://en.wikipedia.org/wikiRKO

http://www.thebeverlyhillshotel.com/special_focus/history.html

http://www.savethederby.com/19690.1.60550.59010/History_of_the_Derby

http://en.wikipedia.org/wiki/Musso_&_Frank's_Grill

http://www.seeing-stars.com/Hotels/HollywoodRoosevelt.shtml

http://www.eastmanhouse.org

http://pinkshollywood.com/pgz/history.htm

http://www.google.com/patents?vid=USPAT2214283&id

http://www.answers.com/topic/history-of-santa-monica-california

http://www.offshore-radio.de/fleet/rex.htm

http://www.answers.con/topic/cinematography

http://www.bartleby.com/65/ca/camera.html

http://library.thinkquest.org/10015/data/info/reference/mechanics/

http://www.mole.com/aboutus/history/smpte/1967-07p671.html

http://en.wikipedia.org/wiki/F-number

http://www.cameraguild.com/interviews/chat_alsobrook/alsobrook_machines1.htm

American Cinematographer Manual, Eighth Edition, edited by Rob Hummel

SPECIAL ACKNOWLEDGMENTS

To my son, DAVID PAUL WERTHEIMER II, whose assistance and computer knowledge made it possible to place a "demo copy" of this book into the publisher' hands, which probably sealed the deal.

To MUSE GREATERSON, a film student and friend, whose gifted and tireless work on this book's illustrations, is very evident and much appreciated. Those who are interested should visit his website: *www.theartofmuse.com*

Finally to BRUCE CAMPBELL, a Renaissance man, an actor, an author, and a filmmaker whose starring roles in *The Evil Dead* and *Army of Darkness* and superb cameos in the *Spiderman* films have simply made him a movie icon... His kind assistance in taking the time to write the Foreword to this book is certainly much appreciated...

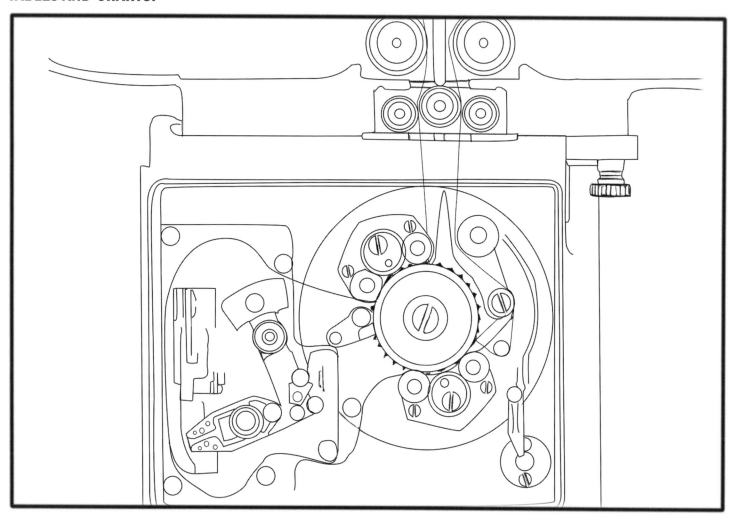

MITCHELL 35MM CAMERA THREADING DIAGRAM

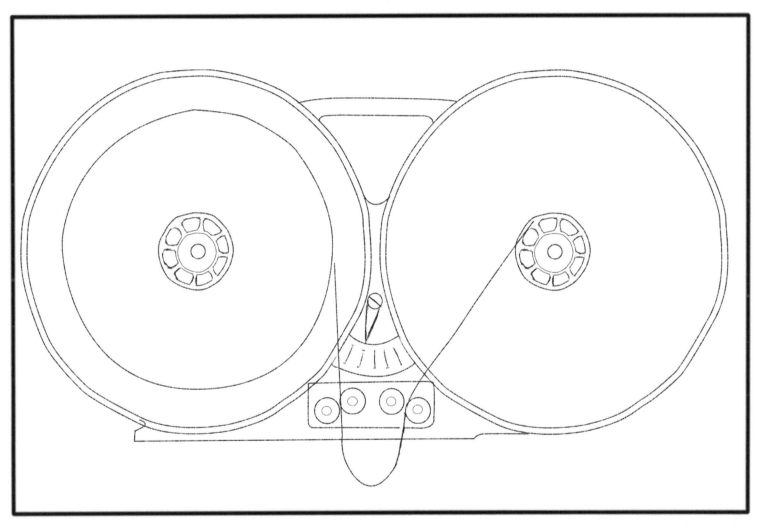

MITCHELL 35MM CAMERA MAGAZINE THREADING DIAGRAM

SELECTED COLOR FILTERS FOR B&W CINEMATOGRAPHY DAYLIGHT EXTERIORS

Kodak Wratten #	Color	Effect / Use	Filter Factor	Stop Increase
3	Light Yellow	Slight Correction	1.5	2/3
6	Yellow	Skies Darker / Objects Appear Gray	2	1
12	Deep Yellow	Skies Darker / For Aerial Cinematography	2	1
15	Deep Yellow	Skies Darker / More Contrast / Tele & Aerial	3	1 2/3
21	Orange	Stronger than #15 / Blue Water Dark	3	1 2/3
23A	Light Red	Moderate Over Correction / Not for Close Ups	5	2 2/3
25	Red	Very Dark Sky / Day for Night / No Faces	8	3
29	Deep Red	Black Sky / Day for Night / No Faces	25	4 2/3
11	Yellow Green	Similar to #8 / Better Skin Tones	2	1
56	Light Green	Darkens Sky / Lightens Foliage	4	2
58	Green	(Comp. Green Separation) Light Foliage/Dark Sky	6	2 2/3
47	Blue	(Comp. Blue Separation) Accentuates Haze	5	2 1/3
23A + 56	–	Dark Sly / Helps Skin Tones for Day for Night	6	2 1/3

Tones for Day for Night

F-STOP COMPENSATION FOR CAMERA SPEED

FPS 6	FPS 12	FPS 24	FPS 48
2.8	2	1.4	1
3.2	2.2	1.6	1.1
3.5	2.5	1.8	1.3
4	2.8	2.0	1.4
4.5	3.2	2.2	1.6
5	3.5	2.5	1.8
5.6	4	2.8	2
6.3	4.5	3.2	2.2
7	5	3.5	2.5
8	5.6	4	2.8
9	6.3	4.5	3.2
10	7	5	3.5
11	8	5.6	4
12.7	9	6.3	4.5
14	10	7	5.6
16	11	8	5
18	12.7	9	6.3
20	14	10	7
22	16	11	8

24 FPS – 35MM FOOTAGE TABLE

FPS 6	FPS 12	FPS 24	FPS 48
2.8	2	1.4	1
3.2	2.2	1.6	1.1
3.5	2.5	1.8	1.3
4	2.8	2.0	1.4
4.5	3.2	2.2	1.6
5	3.5	2.5	1.8
5.6	4	2.8	2
6.3	4.5	3.2	2.2
7	5	3.5	2.5
8	5.6	4	2.8
9	6.3	4.5	3.2
10	7	5	3.5
11	8	5.6	4
12.7	9	6.3	4.5
14	10	7	5.6
16	11	8	5
18	12.7	9	6.3
20	14	10	7
22	16	11	8

INCIDENT KEY LIGHT / T-STOP

ASA	125	64	32	16
2	40	80	160	320
2.2	50	100	200	400
2.5	64	125	250	500
2.8	80	160	320	650
3.2	100	200	400	800
3.5	125	250	500	1000
4	160	320	650	1290
4.5	200	400	800	1625
5	250	500	1000	2050
5.6	320	650	1290	2580
6.3	400	800	1625	3250
7	500	1000	1050	4110
8	650	1290	2580	5160
9	800	1625	3250	6500
10	1000	2050	4100	8200
11	1290	2580	5160	10,000
12.7	1625	3250	6500	—
14	2050	4110	8200	—
16	2580	5160	10,000	—

ABOUT THE AUTHOR

contact David:
davidworthfilm@gmail.com

visit his website:
www.davidworthfilm.com

DAVID WORTH has a résumé of more than thirty feature films as both a Director and a Director of Photography. He was the DP on two features for Clint Eastwood, *Bronco Billy* and *Any Which Way You Can*, before moving into directing and working as a Director/DP in all corners of the world from Hollywood, to Hong Kong, to Israel, to Cape Town, to Bulgaria, and back again.

Along the way he helped launch the career of Jean-Claude Van Damme by being the DP on *Bloodsport* and then the Director on *Kickboxer*. He has also taught at UCLA and directed episodic television, as well as directing and photographing the thrillers, *Time Lapse* with Roy Scheider and *The Prophet's Game* with Dennis Hopper. Most recently he was pleased to work with HD, High Definition, by directing and photographing the micro-budget features, *House at the End of the Drive* and *Honor*, using the SONY 900 HD cameras.

David and his family currently reside in Northern California. He continues to pursue international productions while writing and teaching at The Dodge College of Film and Media Art at Chapman University, The School of Cinematic Arts at USC, and The Department of Theater, Film, and Television at UCLA.

ABOUT THE ILLUSTRATOR

MUSE GREATERSON is only in his twenties, but he has already started to make an impression in the worlds of Art and Film. After graduating from the Institute Auf Dem Rosenberg in Switzerland, he studied a diversity of subjects and cultures throughout Europe, including Art, Literature, Philosophy, History, Theology, Astronomy, and the Cinema, on his own.

He was mentored along the way by the internationally renowned artist Mark Staff Brandl. He also collaborated with Mr. Brandl to create "Metatoons," a video art piece that portrays Mark's unique abstract style. This collaboration was exhibited alongside the masterful works of Mr. Brandl throughout Switzerland. Encouraged by his mentor, Muse started to experiment with photography and the art of storyboarding. This eventually brought him to Chapman University, where he majored in Film Production, graduating in the fall of 2007.

Referring to himself as an "aspiring Renaissance man," Muse continues to pursue art, photography, film, and anything and everything that piques his curiosity. His art and photography can be seen at various galleries around Los Angeles, where he currently resides.

email: *theartofmuse@hotmail.com*
website: *www.theartofmuse.com*

SETTING UP YOUR SHOTS
SECOND EDITION
GREAT CAMERA MOVES EVERY FILMMAKER SHOULD KNOW

JEREMY VINEYARD

This is the 2nd edition of one of the most successful filmmaking books in history, with sales of over 50,000 copies. Using examples from over 300 popular films, Vineyard provides detailed examples of more than 150 camera setups, angles, and moves which every filmmaker must know — presented in an easy-to-use "wide screen format." This book is the "Swiss Army Knife" that belongs in every filmmakers tool kit.

This new and revised 2nd edition of *Setting Up Your Shots* references over 200 new films and 25 additional filmmaking techniques.

This book gives the filmmaker a quick and easy "shot list" that he or she can use on the set to communicate with their crew.

The Shot List includes: Whip Pan, Reverse, Tilt, Helicopter Shot, Rack Focus, and much more.

SETTING UP YOUR SHOTS
GREAT CAMERA MOVES EVERY FILMMAKER SHOULD KNOW / SECOND EDITION
BY JEREMY VINEYARD ILLUSTRATED BY JOSE CRUZ

JEREMY VINEYARD is currently developing an independent feature entitled "Concrete Road" with Keith David (*The Thing, Platoon*) and is working on his first novel, a modern epic.

$22.95 | 160 PAGES
ORDER # 84RLS | ISBN: 1932907424

FROM WORD TO IMAGE
STORYBOARDING AND THE FILMMAKING PROCESS

MARCIE BEGLEITER

BEST SELLER

For over a decade, Marcie Begleiter's acclaimed seminars and workshops have made visual communication accessible to filmmakers and all artists involved in visual storytelling. Whether you're a director, screenwriter, producer, editor, or storyboard artist, the ability to tell stories with images is essential to your craft. In this comprehensive book, Begleiter offers the tools to help both word- and image-oriented artists learn how to develop and sharpen their visual storytelling skills via storyboarding.

Readers are taken on a step-by-step journey into the pre-visualization process, including breaking down the script, using overhead diagrams to block out shots, and creating usable drawings for film frames that collaborators can easily understand. The book also includes discussions of compositional strategies, perspective, and figure notation as well as practical information on getting gigs, working on location, collaborating with other crew members, and much more.

"From Word to Image *examines the how-to's of storyboard art, and is full of rich film history. It demystifies an aspect of filmmaking that benefits everyone involved — from directors, to cinematographers, to production designers."*

— Joe Petricca, Vice Dean,
American Film Institute

"*Begleiter's process is a visual and organizational assist to any filmmaker trying to shift from story in words to story in moving image."*

— Joan Tewkesbury, Screenwriter, Nashville;
Director, *Felicity*

"From Word to Image *delivers a clear explanation of the tools available to help a director tell his story visually, effectively, and efficiently — it could be subtitled 'A Director Prepares.'"*

— Bruce Bilson, Emmy® Award-Winning
Director of over 350 television episodes

MARCIE BEGLEITER is a filmmaker and educator who specializes in pre-visualization. She is the owner of Filmboards, whose clients include Paramount, New Line, HBO, ABC, and Lightspan Interactive.

$26.95 | 224 PAGES
ORDER # 45RLS | ISBN: 0941188280

MICHAEL WIESE PRODUCTIONS

Since 1981, Michael Wiese Productions has been dedicated to providing both novice and seasoned filmmakers with vital information on all aspects of filmmaking. We have published more than 100 books, used in over 600 film schools and countless universities, and by hundreds of thousands of filmmakers worldwide.

Our authors are successful industry professionals who spend innumerable hours writing about the hard stuff: budgeting, financing, directing, marketing, and distribution. They believe that if they share their knowledge and experience with others, more high quality films will be produced.

And that has been our mission, now complemented through our new web-based resources. We invite all readers to visit www.mwp.com to receive free tipsheets and sample chapters, participate in forum discussions, obtain product discounts — and even get the opportunity to receive free books, project consulting, and other services offered by our company.

Our goal is, quite simply, to help you reach your goals. That's why we give our readers the most complete portal for filmmaking knowledge available — in the most convenient manner.

We truly hope that our books and web-based resources will empower you to create enduring films that will last for generations to come.

Let us hear from you at anytime.

Sincerely,
Michael Wiese
Publisher, Filmmaker

www.mwp.com

FILM & VIDEO BOOKS

Archetypes for Writers: *Using the Power of Your Subconscious*
Jennifer Van Bergen / $22.95

Art of Film Funding, The: *Alternate Financing Concepts*
Carole lee Dean / $26.95

Cinematic Storytelling: *The 100 Most Powerful Film Conventions Every Filmmaker Must Know* / Jennifer Van Sijll / $24.95

Complete Independent Movie Marketing Handbook, The: *Promote, Distribute & Sell Your Film or Video* / Mark Steven Bosko / $39.95

Creating Characters: *Let Them Whisper Their Secrets*
Marisa D'Vari / $26.95

Crime Writer's Reference Guide, The: *1001 Tips for Writing the Perfect Crime*
Martin Roth / $20.95

Cut by Cut: *Editing Your Film or Video*
Gael Chandler / $35.95

Digital Filmmaking 101, 2nd Edition: *An Essential Guide to Producing Low-Budget Movies* / Dale Newton and John Gaspard / $26.95

Directing Actors: *Creating Memorable Performances for Film and Television*
Judith Weston / $26.95

Directing Feature Films: *The Creative Collaboration Between Directors, Writers, and Actors* / Mark Travis / $26.95

Elephant Bucks: *An Insider's Guide to Writing for TV Sitcoms*
Sheldon Bull / $24.95

Eye is Quicker, The: *Film Editing; Making a Good Film Better*
Richard D. Pepperman / $27.95

Fast, Cheap & Under Control: *Lessons Learned from the Greatest Low-Budget Movies of All Time* / John Gaspard / $26.95

Fast, Cheap & Written That Way: *Top Screenwriters on Writing for Low-Budget Movies* / John Gaspard / $26.95

Film & Video Budgets, *4th Updated Edition*
Deke Simon and Michael Wiese / $26.95

Film Directing: *Cinematic Motion, 2nd Edition*
Steven D. Katz / $27.95

Film Directing: *Shot by Shot, Visualizing from Concept to Screen*
Steven D. Katz / $27.95

Film Director's Intuition, The: *Script Analysis and Rehearsal Techniques*
Judith Weston / $26.95

Film Production Management 101: *The Ultimate Guide for Film and Television Production Management and Coordination* / Deborah S. Patz / $39.95

Filmmaking for Teens: *Pulling Off Your Shorts*
Troy Lanier and Clay Nichols / $18.95

First Time Director: *How to Make Your Breakthrough Movie*
Gil Bettman / $27.95

From Word to Image: *Storyboarding and the Filmmaking Process*
Marcie Begleiter / $26.95

Hollywood Standard, The: *The Complete and Authoritative Guide to Script Format and Style* / Christopher Riley / $18.95

Independent Film Distribution: *How to Make a Successful End Run Around the Big Guys* / Phil Hall / $26.95

Independent Film and Videomakers Guide – 2nd Edition, The: *Expanded and Updated* / Michael Wiese / $29.95

Inner Drives: *How to Write and Create Characters Using the Eight Classic Centers of Motivation* / Pamela Jaye Smith / $26.95

I'll Be in My Trailer!: *The Creative Wars Between Directors & Actors*
John Badham and Craig Modderno / $26.95

Moral Premise, The: *Harnessing Virtue & Vice for Box Office Success*
Stanley D. Williams, Ph.D. / $24.95

Myth and the Movies: *Discovering the Mythic Structure of 50 Unforgettable Films* / Stuart Voytilla / $26.95

On the Edge of a Dream: *Magic and Madness in Bali*
Michael Wiese / $16.95

Perfect Pitch, The: *How to Sell Yourself and Your Movie Idea to Hollywood*
Ken Rotcop / $16.95

Power of Film, The
Howard Suber / $27.95

Psychology for Screenwriters: *Building Conflict in your Script*
William Indick, Ph.D. / $26.95

Save the Cat!: *The Last Book on Screenwriting You'll Ever Need*
Blake Snyder / $19.95

Save the Cat! Goes to the Movies: *The Screenwriter's Guide to Every Story Ever Told* / Blake Snyder / $24.95

Screenwriting 101: *The Essential Craft of Feature Film Writing*
Neill D. Hicks / $16.95

Screenwriting for Teens: *The 100 Principles of Screenwriting Every Budding Writer Must Know* / Christina Hamlett / $18.95

Script-Selling Game, The: *A Hollywood Insider's Look at Getting Your Script Sold and Produced* / Kathie Fong Yoneda / $16.95

Selling Your Story in 60 Seconds: *The Guaranteed Way to get Your Screenplay or Novel Read* / Michael Hauge / $12.95

Setting Up Your Scenes: *The Inner Workings of Great Films*
Richard D. Pepperman / $24.95

Setting Up Your Shots: *Great Camera Moves Every Filmmaker Should Know*
Jeremy Vineyard / $19.95

Shaking the Money Tree, 2nd Edition: *The Art of Getting Grants and Donations for Film and Video Projects* / Morrie Warshawski / $26.95

Sound Design: *The Expressive Power of Music, Voice, and Sound Effects in Cinema* / David Sonnenschein / $19.95

Special Effects: *How to Create a Hollywood Film Look on a Home Studio Budget* / Michael Slone / $31.95

Stealing Fire From the Gods, 2nd Edition: *The Complete Guide to Story for Writers & Filmmakers* / James Bonnet / $26.95

Ultimate Filmmaker's Guide to Short Films, The: *Making It Big in Shorts*
Kim Adelman / $16.95

Way of Story, The: *The Craft & Soul of Writing*
Catherine Anne Jones / $22.95

Working Director, The: *How to Arrive, Thrive & Survive in the Director's Chair*
Charles Wilkinson / $22.95

Writer's Journey, – 3rd Edition, The: *Mythic Structure for Writers*
Christopher Vogler / $26.95

Writing the Action Adventure: *The Moment of Truth*
Neill D. Hicks / $14.95

Writing the Comedy Film: *Make 'Em Laugh*
Stuart Voytilla and Scott Petri / $14.95

Writing the Killer Treatment: *Selling Your Story Without a Script*
Michael Halperin / $14.95

Writing the Second Act: *Building Conflict and Tension in Your Film Script*
Michael Halperin / $19.95

Writing the Thriller Film: *The Terror Within*
Neill D. Hicks / $14.95

Writing the TV Drama Series – 2nd Edition: *How to Succeed as a Professional Writer in TV* / Pamela Douglas / $26.95

DVD & VIDEOS

Field of Fish: *VHS Video*
Directed by Steve Tanner and Michael Wiese, Written by Annamaria Murphy / $9.95

Hardware Wars: DVD / Written and Directed by Ernie Fosselius / $14.95

Sacred Sites of the Dalai Lamas– DVD, The: *A Pilgrimage to Oracle Lake*
A Documentary by Michael Wiese / $24.95

To Order go to www.mwp.com or Call 1-800-833-5738